The

PASTELIST'S
YEAR

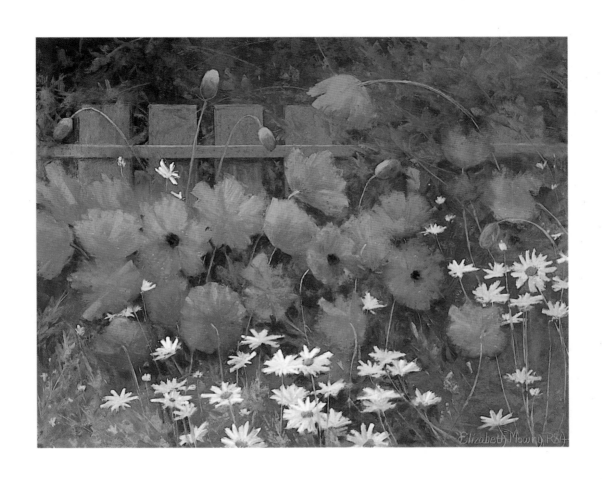

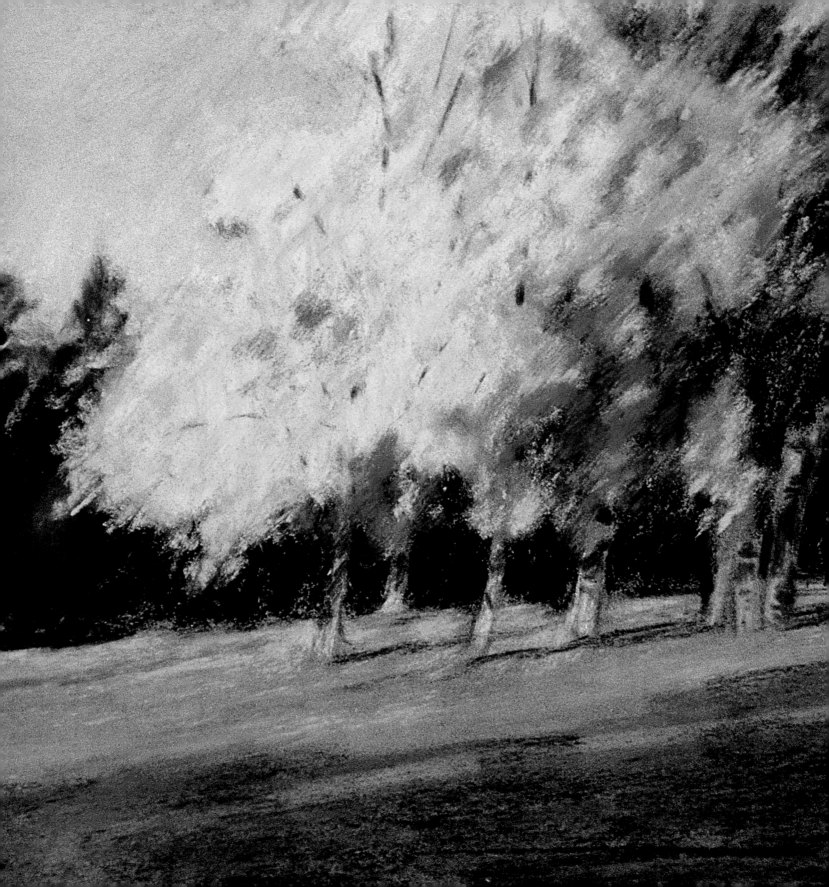

The
PASTELIST'S YEAR

Painting the Four Seasons in Pastel

ELIZABETH MOWRY

WATSON-GUPTILL PUBLICATIONS / NEW YORK

Front cover
ELIZABETH'S COLOR PATCH CALENDAR
Pastel on Sennelier, 2" (5 cm) square for each month.

Frontispiece
POPPIES AT THE FENCE
Pastel on Wallis paper, 18 × 23" (46 × 59 cm).

Title page
GOLDEN HILL (detail)
Pastel on Sennelier La Carte, 5$\frac{1}{2}$ × 9$\frac{1}{2}$" (14 × 24 cm).

Page 5
SAWKILL GOLD II
Pastel on Wallis paper, 6 × 8" (15 × 20 cm). Private collection.

Contents page
SUNFLOWERS III
Pastel on toned, sanded paper, 11 × 13" (28 × 33 cm).

Senior Acquisitions Editor, Candace Raney
Edited by Robbie Capp
Designed by Areta Buk
Graphic production by Ellen Greene
Text set in Berling

First Published in 2001 by Watson - Guptill Publications
Nielsen Business Media, a division of The Nielsen Company
770 Broadway, New York, NY 10003
www.watsonguptill.com

Library of Congress Control Number 2001087411

ISBN 0-8230-3935-8

Printed in China

Second printing, 2001

4 5 6 7 8 9 / 09 08 07

Acknowledgments
With heartfelt gratitude to Candace Raney, who liked the
idea for my book years ago and proposed this edition, and
to my editor, Robbie Capp, and designer, Areta Buk, for
their expertise in creating a beautiful new look. For
graphic production by Ellen Greene and the editorial
assistance of Alicia Kubes, I thank you.

To all of my students, this book is for you.

I have truly enjoyed our time together:

the honest sharing, like blank pages filling, overflowing;

like painting surfaces saturated with the colors and compositions of life;

the dialogue as with grasses in the breeze;

the ideas, invited, free, about the ethereal sense of place

and common sense;

the balancing of emotional connection with the craft, enthusiasm with skill—

as well as the agony of frustration with the ecstasy of what works;

the friendships that began in my classes and continue; our joy for one another

as the rewards earned begin to appear on the horizon.

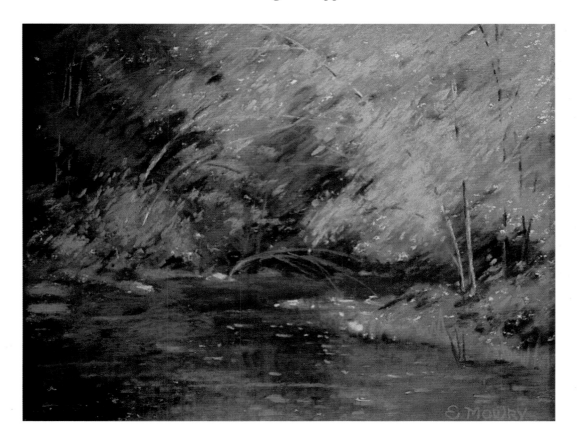

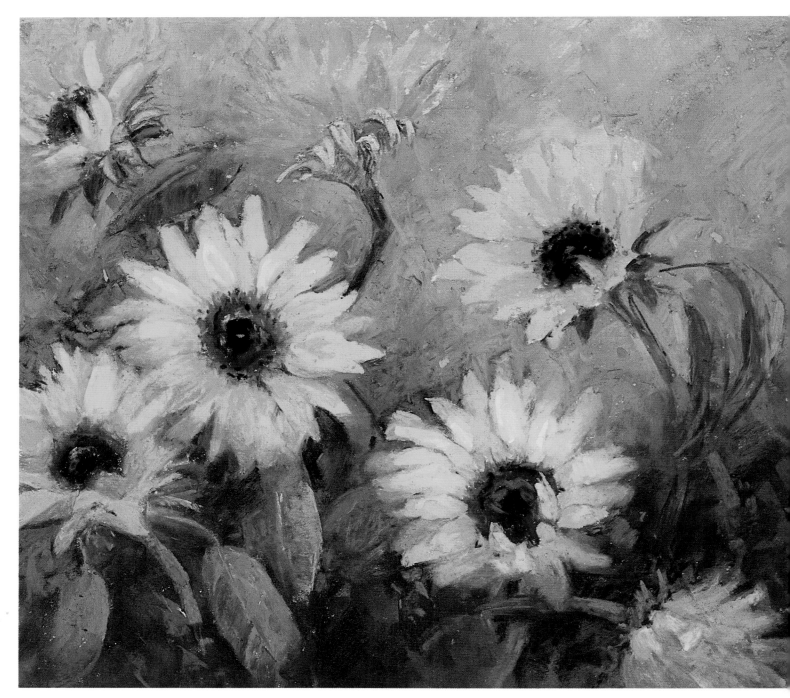

SUNFLOWERS III

Pastel on toned, sanded paper, 11 × 13" (28 × 33 cm).

CONTENTS

Elizabeth Mowry

Introduction

NATURE AS TEACHER

The enduring harmony of nature's landscape, even as the seasons change, has evolved over the years as the abiding source of most of my work. Nature was my first teacher. I learned about it by being in it, day after day, season to season. I was enticed by its beauty, humbled by its surprising exceptions, and gently nudged to look more and more carefully at its intricacies until, eventually, I began to *see*— that hills in the distance were smaller and less distinct, that distance is expressed by using cooler colors, smaller proportions, and softer edges—so that was how I painted them. In addition to those discoveries, in these pages, I wish to share all that I have learned from nature's lessons after years of assimilation and sorting.

The first chapter offers detailed notes about materials, plus demonstrations of basic techniques to help you get started. Each of the next four chapters is devoted to a season of the year. A final chapter explores the joys of plein-air painting with pastels on travel adventures near and far.

At the beginning of each of the seasons chapters, you will find material culled from my journal. These "paintings in the mind" suggest what to look for at a particular time of year as you make a connection with your subject matter and choose a certain place and vantage point over others when many are accessible. I invite you to follow the thought patterns that lead to selection of subject, color, and mood. Remember that it is our response to all of the senses that constitutes the emotional essence of a painting.

The demonstrations and examples throughout this book show the relationship between each pastel technique and its place within the finished work. Notes about color selection, use of materials, value, and composition are blended into each season's approach to painting nature. This revised, enlarged version of an earlier book that I wrote about painting the seasons contains artwork from the former edition, but there are also numerous additional works that illustrate further pastel techniques that you can use to express nature's seasonal changes most effectively. I hope that what I have learned so laboriously by trial and error will save you time.

Just as important, this book shows you how I translate seasonal *impressions* into personal *expressions*. Know with certainty that you can do the same. Of course, each of us sees differently. Personally, I paint what I know best, so activities in my garden, kitchen, and studio spill into and enrich one another. While nature supplies shape and movement, light and shadow, sound and scent, what we create with them depends on what lies within ourselves. Our feelings about life—our memories, longings, fears, and joys—influence how we perceive all that surrounds us. My aim is to show you how to translate what you see into what you paint—blending the emotional response to nature's seasons with an ever-growing mastery of pastelist skills.

DUET
Pastel on mounted Ersta paper, 5 × 5" (13 × 13 cm). Private collection.

In this little outdoor color study, I was interested primarily in the shapes and coloration of the apples and leaves. Values (lights and darks) were important here. This is an example of a simple subject presenting an opportunity to learn many lessons on a small surface.

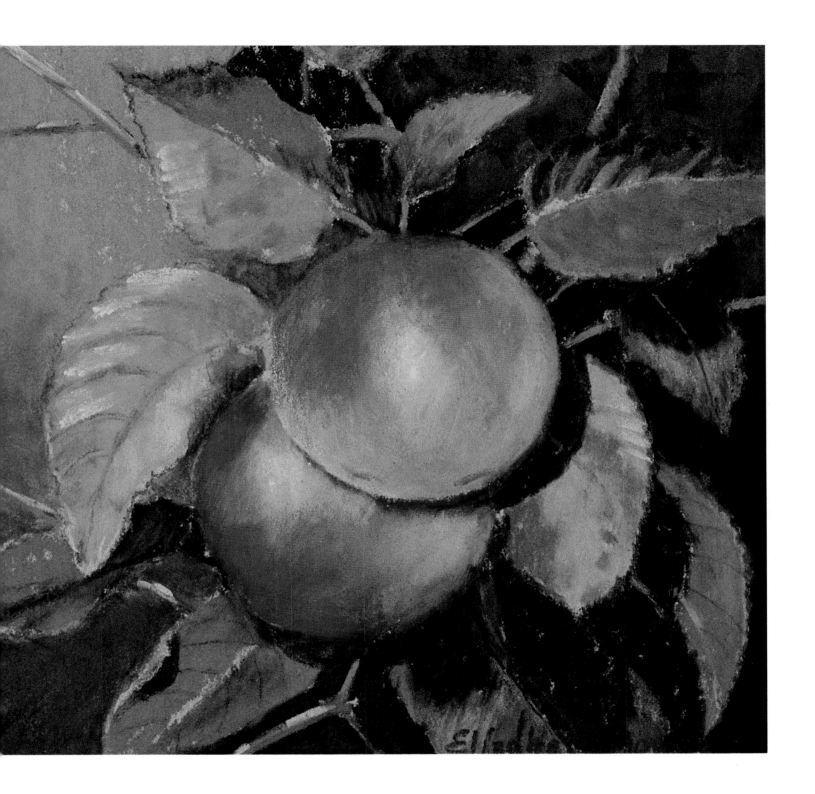

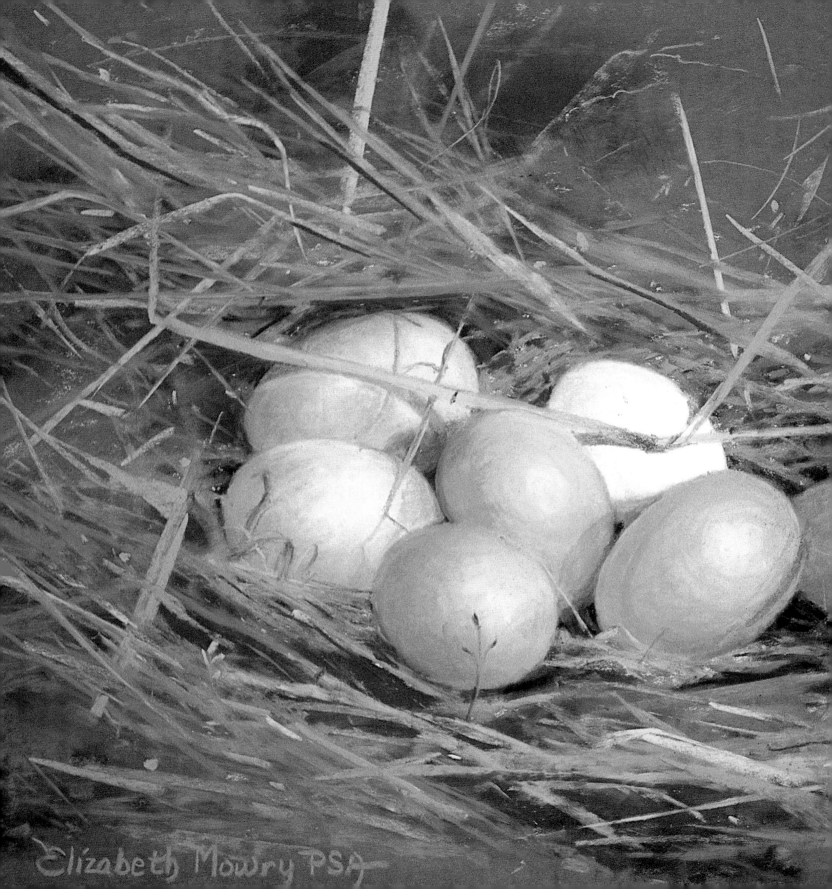

Elizabeth Mowry PSA

1
Beginnings

Within the same painting, broad and bold painting strokes create a dialogue with linear drawing strokes. Stroke variation can often strengthen the compositional design of a painting.

NOTES TO THE BEGINNING PASTELIST

If you are new to pastel, I hope that you won't be intimidated by the term *technique*. A reassuring definition, according to Webster, tells us that technique is simply "an artist's special method of execution used to obtain a certain result." This book shows methods that work for me, and I'll be right alongside you to lend encouragement. You'll find that the process of actually painting—the learning that comes from applying what you have discovered—is all there is to mastering a technique. You can watch someone else do it, you can read about it to enhance your understanding, but you'll always learn best by *doing* it—even if poorly at first.

Before attending a class or even attempting a painting, spend time making friends with your pastels. Examine and handle the tools of your new medium, and try using them on a few different surfaces. Get a feel for holding pastels. Variations in applied pressure make a difference in the resulting marks on your surface. Practice a light touch, and don't be afraid to break pastels into pieces to get the stroke shapes that you want.

You don't need a formula for everything you try in pastel. There are many, to be sure, but early dependence on set methods will stifle your creativity. To begin, I suggest that you get your idea down on the painting surface in any way that you can with whatever materials you have. As you progress, work at getting your idea down cleaner (less buildup), more directly (less fussing), and quicker (decide beforehand what you are after). This approach will help your work become more expressive as you grow more comfortable with pastels. Your work will gradually exhibit the sparkle that is inherent to pastel paintings that are not overworked.

Sketching with Pastels
Pastels can be used for drawing. The end result is a sketch that involves very little layering and a minimal background; in other words, a vignette. A pastel sketch does not cover the entire surface or go to the edges of the paper. The artist doesn't have to make decisions as to whether to put background in first or tuck it around the center of interest later.

While sketching, you become accustomed to your pastels gradually. You will need a good-quality paper and some blending stumps or tortillons (see "About Materials"). Because this book is primarily about painting—particularly landscape painting—you will notice that I do not encourage the use of fingers to blend color, because other methods of blending usually give better results for landscapes. However, when *sketching* with pastels, you may need to use your fingers as an extra tool for obtaining softened effects.

Painting with Pastels
Many pastelists use a combination of drawing and painting techniques in their work. When used as a painting medium, pastel is stroked across an abrasive surface in layers, and it completely covers the painting ground. Put a layer of colors on a painting surface and cover it with a layer of another color, allowing some of the first colors to show through. See how layering can cause your colors to vibrate. Keep adding more color layers. Observe how each different surface looks when you have filled its "tooth" (roughness of the paper surface) to capacity. What happens after that? Additional pastel falls off most surfaces and they begin to feel slippery. This is probably the most important experiment you will ever do. When your painting surface no longer holds the pastel, you have discovered the pastelist's equivalent of the oil painter's or watercolorist's "mud," or as I think of it, "the point of no return" in a pastel painting.

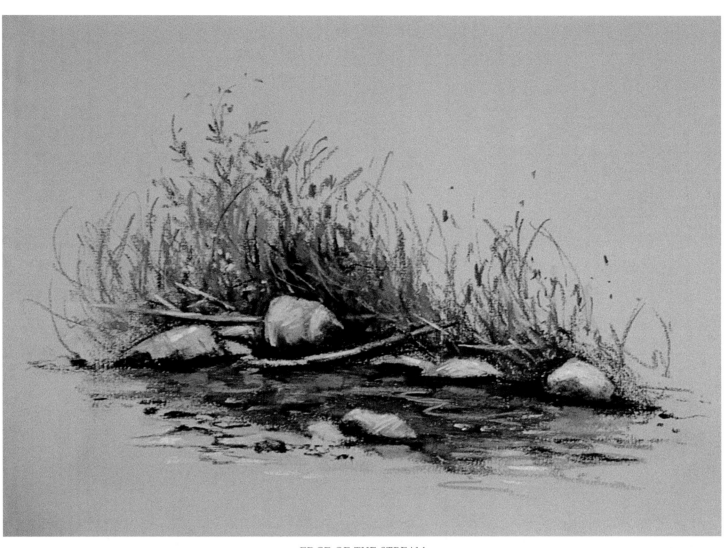

EDGE OF THE STREAM

Pastel on Daler Ingres Paper, 9 × 12" (23 × 31 cm). Collection of Kathy Kipp.

When sketching with pastels, you can focus directly on the center of interest without the concern or distraction of getting a background to work.

EXERCISES: *Basic Strokes*

1: CLOSED STROKE. *Fill a circle with closed strokes. These occur when one stroke is placed directly next to or overlapping the previous stroke. (This step and the next two are useful in learning to paint water with pastels.)*

2: OPEN (OR BROKEN) STROKE. *Fill a second circle with open strokes. These have space around and between them. They may be sporadic or in a pattern.*

3: OPEN STROKES OVER CLOSED. *Fill a third circle with open (or broken) strokes placed over a layer of closed strokes.*

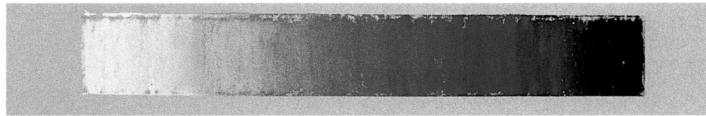

4: GRADUATED COLOR/VALUE PATCHES. *Top, make a color strip showing a graduated order of color. This is actually a value scale; keep the values separate. (This exercise is helpful for understanding the painting of skies with easily blended soft pastels. Also see "Values" in "Summer" chapter.)*

5: BLENDED COLOR/VALUE PATCHES. *Bottom, blend your color values into one another to show a smooth gradation from left to right and from right to left. Do this by pulling some of each of the colors into the color directly beside it with your pastels. Any two or more colors can be blended in this manner on an abrasive surface on which there is ample pastel. No fingers are necessary. (This exercise is also useful for painting skies.)*

6: SIDE STROKE. *Use a pastel piece on its side and pull it evenly and lightly over a large area (useful for describing background growth or foliage). This side stroke is a quick way to put in a first layer of pastel in your painting, and it can be done with soft or hard pastels.*

7: SIDE STROKES USING SAME-VALUE COLORS. *Note how colors appear to blend with one another.*

8: SIDE STROKES USING DIFFERENT-VALUE COLORS. *Again using side strokes going in many directions, a pattern of contrasts will begin to appear.*

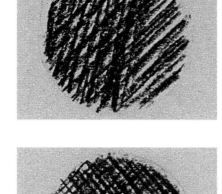

9: CROSSHATCHING. *Fill a circle with crosshatch strokes using the same color in two directions. (This versatile stroke can put life back into areas that become overblended or appear lifeless.)*

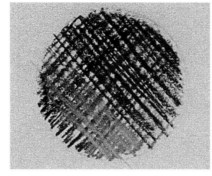

10: CROSSHATCHING WITH DIFFERENT COLORS. *Fill a circle with crosshatch strokes using a few colors in several directions.*

11: HARD EDGES. *This exercise is useful in representing man-made landscape shapes such as barns, fences, or other hard-edged objects when a crisp, sharp demarcation of color is desired.*

12: SOFT EDGES. *To discover how the soft edges found in distant mountains, hills, and clouds are achieved, layer some colors onto your pastel surface. Where colors meet, blur the edge with a tortillon (see "Blending Tools") or a pastel pencil or hard pastel. For example, if you have a horizontal mountain line, the push will be vertical, across the line to soften it. Usually it is more effective to push parts of a line and leave other parts intact.*

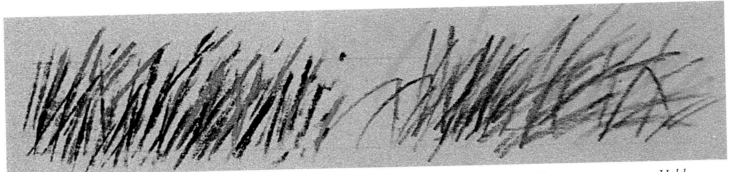

13: SCRIBBLE STROKE. *A diagonal* scribble *stroke can be made with either pastels or pastel pencils to represent grasses. Hold your pencil farther away from the point than you usually do for free and expressive movement.*

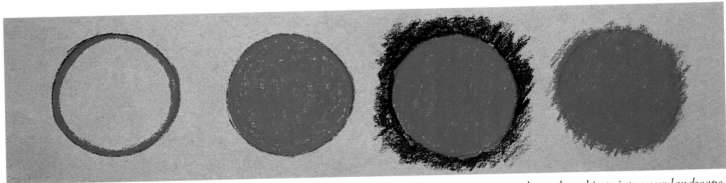

14: DIFFERENT APPROACHES TO SHAPE. *Here are two different approaches to putting natural or other objects into your landscape. Left, to make a shape, you can draw it in outline, then fill it in. Right, approaching the same circular shape from the opposite direction would begin with an approximation of the shape itself (far right). The shape becomes refined and adjusted by the colors that eventually surround it and push into it. (This approach is useful when defining foliage groups in trees and shrubs.)*

The previous stroking exercises will give you a jump start at getting your pastels to produce the results that you want to achieve.

What you gain from spending quality time that combines motor activity with intense focus of attention is yours always, to use and to build upon. And it is best to spend this time early on. In that way, when painting out in the field, you can work spontaneously and with feeling. Otherwise, the struggle with basic techniques will very likely inhibit your creativity, and it may affect the quality of your work.

And finally, remember that observation is a large part of an artist's life. Even when you are not painting, you are still an artist. Observation continues, and with awareness, your ability to use what you see will expand. Sometimes paintings will result; other times, they will not. However, the mind stores the information that you focus on, so that it is retrievable when needed. Make use of your heightened observation before you paint to find your composition, throughout your work process as you make comparisons between your subject and your painting, and, finally, after you paint, for sharper evaluation of your work.

DEMONSTRATION: *Painting Simple Shapes in Pastel*

Small-scale exercises are excellent for learning about form, light, strokes, backgrounds, and making adjustments throughout your painting process. Beginning with a few simple objects, you can build confidence as well as familiarity with your pastels as you gradually change flat color shapes into modeled ones. Notice where the light on objects comes from and how it affects the color of those objects. Light also throws part of the objects into shadow and, under light, the objects themselves cast shadows. Next, adding even a minimal background gives the objects a setting. Then, final all-over adjustments, including highlights and a few details, bring your subject to life. Remember: Keep it very simple at first.

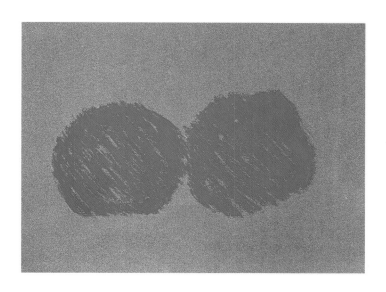

STEP 1: SKETCH THE SHAPES.
Above, on a 7 × 9¹/₂" (18 × 23 cm) piece of La Carte pastel surface, I sketch the approximate shapes of two pomegranates, using the tip of a medium-red, soft pastel in diagonal strokes.

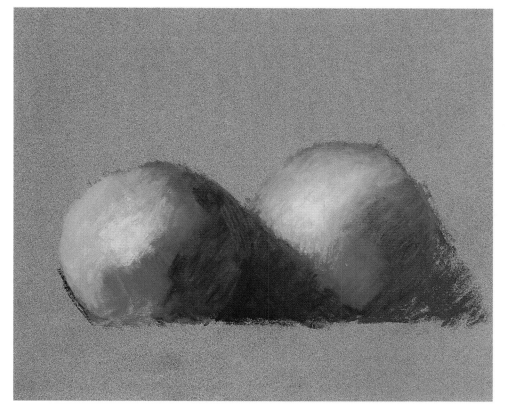

STEP 2: ADD LIGHT AND SHADOW.
Now, I put some light on the subject to achieve form. The source of light is from upper left, so I make that part of each pomegranate appear lighter with a color change to ochre and yellow, applied with a crosshatch stroke on top of the red. I pull each color into the hue next to it so that color transitions blend gradually. The lower right of each pomegranate, which receives less light, is made darker with lower value, dark red-brown. At this point, I stroke in the cast shadows as well.

STEP 3: STROKE IN THE BACKGROUND. *Next, I give the pomegranates a setting, first using brown soft pastel to suggest a wooden ledge for the fruits to rest upon. Then I stroke in a minimal background, using two values of purple pastel, coming right up to and refining the edges of the pomegranates. To avoid a coloring-book look, it's preferable not to outline objects when painting with pastels. Instead, allow some of the object's edges that are turning away from you to become softly lost.*

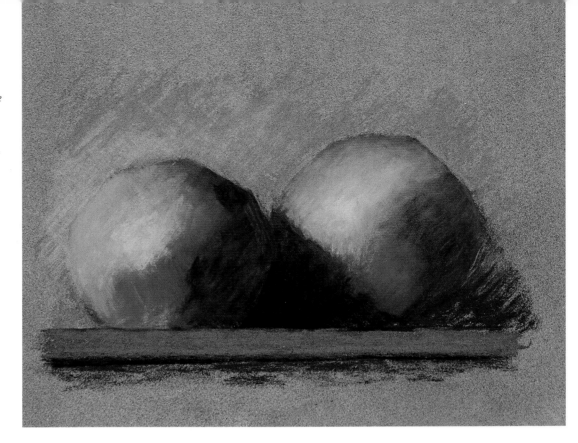

PAIR OF POMEGRANATES
Pastel on Sennelier La Carte,
7 × 9¹/₂" (18 × 24 cm).

STEP 4: MAKE FINAL ADJUSTMENTS. *Finally, take a fresh look at your work to find where adjustments are needed. In this case, I heightened the lighted area of each pomegranate with a lighter (higher value) yellow, then freshened up dull areas with crosshatching. Details at the top of each fruit are drawn in with pastel pencils, and I warmed up the background by crosshatching some red-violet over the blue-purples.*

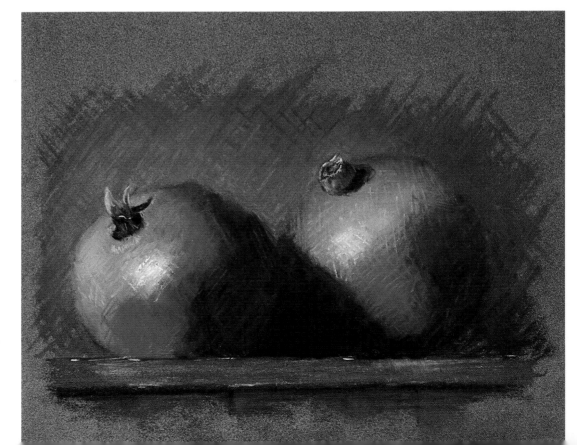

20

NOTES TO THE ADVANCED PASTELIST

When I paint a scene for the first time, the result is often quite literal. But as I explore the same place through additional paintings, I am released from literal interpretation, and my work becomes more expressive through variety in composition, light, and color. I feel liberated and enjoy experimenting with different times of day, different seasons, and even changed weather conditions.

As we examine the same scene at different times, the direction of our painting grows more inward. When we know the landscape intimately, our mind goes beyond *what is* and becomes free to explore adventuresome color, fluid movement, or whatever enters. This freedom occurs because the specifics of the place are already known and make no demands upon our concentration.

When I feel compelled to paint a scene more than once, even many times, it is as though I am coaxing nature's secrets to unfold. The resulting circular effect is that my own awareness expands. My attention intensifies to where I see not only seasonal but monthly changes, and then weekly, and even daily ones. The revealing and unraveling of nature's tiny intimacies is extremely uplifting, and I regard it as a solemn gift. The ideas that occur at this level of awareness are deep and fundamental, and many times, abstract. Pursued, they have the potential to influence our work and our lives.

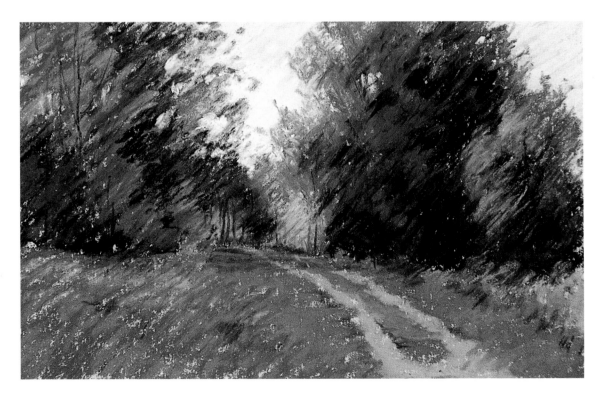

PATHWAY, MAINE
Pastel on sanded board,
6¹/₂ × 10" (17 × 25 cm).
Private collection.

The first time I saw this spot, I recorded it using soft pastels in loose, open strokes, being faithful to the greens that were there. I was mainly interested in the subtle value relationships.

21

LANDSCAPE LIGHT
Pastel on sanded board,
9 × 18" (23 × 46 cm).
Private collection.

My second interpretation broadens the scene. Having already painted a more literal view, I pushed the foliage colors by introducing soft blues and reds. The use of loose strokes with the soft pastels blends the colors and adds interest to the painting without disrupting the harmony.

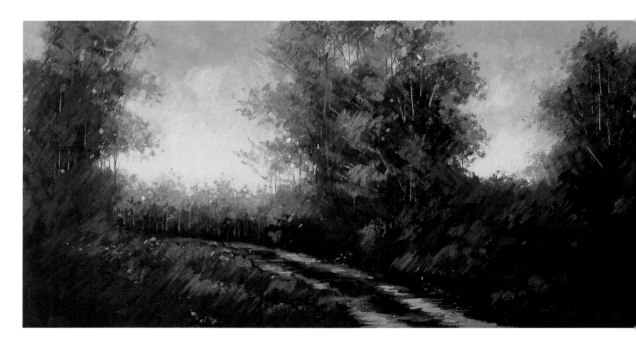

END OF DAY, MAINE
Pastel on sanded board,
9 × 18" (23 × 46 cm).
Private collection.

In my third interpretation, I was completely free of the reality of the scene. It was time for playing joyously with the simplicity of light and dark space, choosing colors with utter disregard for the literal. I used purples for distance and low-value reds, greens, and violets for the shapes against the pink and blue gray of the sky. The stroke, using all soft pastels, is predominately diagonal except at the foliage edges and the path.

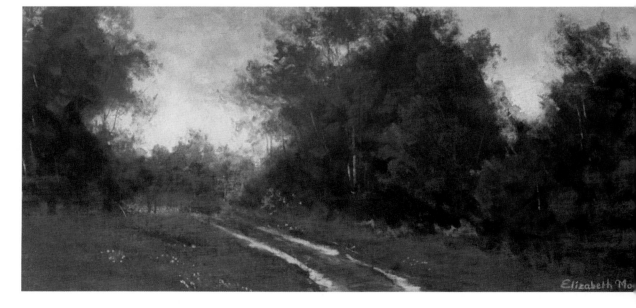

22

ABOUT MATERIALS

Substantial differences among various brands of pastels and pastel surfaces require your thoughtful experimentation before making a serious investment in supplies. Instructors who advise students to try a varied sampling are not evading questions; it's really the only way to find which materials are best for you. Your style of painting, the subject matter you choose, and your vision of the desired result in your work will influence your preferences in materials. Even individual temperament can affect the quality and pressure of your pastel stroke. By trying a range of materials, you will avoid locking yourself into a commitment to tools that are less than optimal for you.

The ever-growing list of new materials available to today's pastel artist makes any attempt at a comprehensive, up-to-date evaluation virtually impossible, even in books devoted to the subject. Therefore, the following overview is offered just to introduce beginning pastelists to the basic tools of the medium.

Soft Pastels

It is important to have a broad selection of pastels. Some teachers even insist on a minimum number—a stipulation meant to reduce the frustration that students feel when they lack an adequate range of colors and values needed to take advantage of the instruction being given.

Among the many brands of high-quality soft pastels on the market are those made by Sennelier, Pastels Girault, Unison, Rowney, Schmincke, and Diane Townsend. Once you find the brand that you like, invest in a set offering the largest assortment that you can afford; after that, buy single sticks. You will find that muted colors are more suited to landscape than the bright hues you might want for still life. Buying small beginner's sets of pastels may add to your total number of sticks, but this plan leaves you with a very limited value range and too many duplications of colors deemed basic by manufacturers. How many

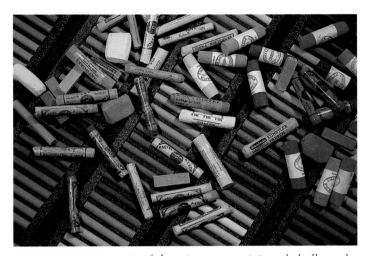

SOFT PASTELS *consist of dry pigment, precipitated chalk, and a binder, usually gum tragacanth. The less there is of binder, the softer the pastel. As the name implies, these sticks are soft in texture so that compared with hard pastels, they leave more pigment on your painting surface with each stroke and are the easiest to blend. Soft pastels come in a variety of shapes, and some have a paper wrapper. Some of the soft pastel brands preferred by professional pastelists are pictured here.*

cadmium orange-medium pastels do you need for landscape painting? Instead, after owning one sizable set, start to accumulate more of the subtle colors found in nature. Pastel artists are notorious for succumbing to a mysterious weakness that surfaces in art supply stores as they stand before displays of luscious, rolled color sticks. That is the time to add a few seasonal subtle hues to your collection.

Hard Pastels

The hard pastels preferred by many instructors are NuPastel, Greta Color, and Holbein. Working with the edges of short, broken pieces of these harder pastels will give a crisp stroke definition that is sometimes required. The edges of hard pastels can be freshened on a sanding block.

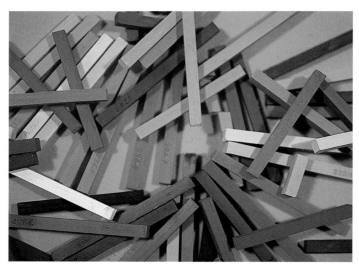

HARD PASTELS, *made with a greater amount of binder, are harder and more dense than soft pastels. They are generally rectangular with squared edges that make it possible to draw fine lines. Lightly applied, they can substitute for a blending tool. Broken in pieces, they are useful during the initial block-in of a painting and again for final detail, and they can be sharpened on a sanding block.*

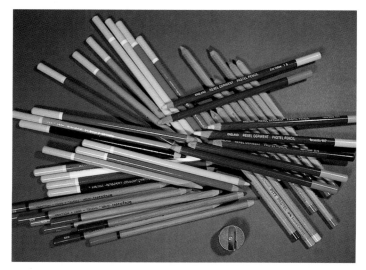

PASTEL PENCILS *are pastels in pencil form and must not be confused with colored pencils. They are convenient for doing small studies and for drawing. Pastel pencils can be sharpened to a fine point, producing the very thin lines required for detail work.*

Pastel Pencils

Several brands of improved pastel pencils have become available recently. Excellent are those by Derwent, Faber Castell, Bruynzeel, and Carbothello by Stabilo. All fit into a standard sharpener, being the same diameter as a regular pencil, and all feel comfortable in my hand in the many positions in which I use them. To sharpen pastel pencils, I use a common wall-mounted sharpener or an electric sharpener when at work in my studio, and a tiny twist sharpener outdoors. Some new small sharpeners come with replacement blades. If the blade is sharp, the pastel inside the pencil is less likely to break.

Papers and Their Surfaces

Paper surface is the most important consideration for pastel artists. Therefore, the best papers for painting with pastel are those that have a sanded, abrasive surface, sometimes referred to as grit, or tooth. When pastels are stroked across this granular surface, the color becomes embedded in it. A sanded texture provides adhesion for dry pigment, although sometimes its rough tooth can barely be felt when passing one's hand over the paper. Smooth surfaces cannot hold much dry pigment, but they do work well for sketching and drawing. But pastel painters mainly look for surfaces with an abrasive texture that suit their own style of work, much the way watercolorists select papers to suit their particular styles.

Wallis paper, in professional and museum grades, was developed and perfected by a pastel artist who realized a need for a superior abrasive pastel paper that was neutral pH (acid-free). It has become very popular and is recommended by many professionals. Its durable white surface can be underpainted in various pigment mediums and will withstand scrubbing with water or turpentine before reworking. Wallis paper is available in pads, sheets, and rolls.

Also for painting with pastels, La Carte Pastel Board by Sennelier is an excellent surface. This is a pH-neutral board with a slightly abrasive, uniform tooth for dry media only. It is available in sheets in two sizes and in many colors.

PASTEL SURFACES FOR PAINTING *include the white surface shown, Wallis paper; the buff-colored paper, Ersta; and the three colors offered by Sennelier La Carte.*

PASTEL SURFACES FOR DRAWING *include three of the colored papers made by Daler Rowney and three made by Larroque Bergerac.*

Ersta Starke, a buff-colored, sanded paper made in Germany, comes in fine, extra-fine, and super-fine grit. I prefer the fine grit. This paper is available in sheets and also in rolls for large work, but the pieces cut from rolls tend to curl up unless drymounted. Except when you need the larger size, sheets are more convenient. Water tends to damage the grit of Ersta paper, and it is not pH neutral.

It may be toned by brushing diluted, turpentine-based wood stain (the undisturbed liquid at the top of the can) over the surface and allowing it to dry thoroughly. It can also be toned by turping in a light layer of hard pastel that has been applied to the paper. This keeps the tooth of the sanded paper open so that many subsequent layers of pastel will adhere to the surface.

Partially toned surfaces can be prepared by staining only areas where you know you will want dark values in your painting; a value sketch will tell you where those areas are. Another approach to obtaining large areas of accurate color and value on a light surface is to underpaint. This involves applying color to your surface with hard pastels that will not clog the tooth of the paper, then brushing pastel into the surface using a polyfoam brush that's been dipped in Turpenoid. The polyfoam brush gives an even distribution of color and won't leave lint or brush hairs on your work. Allow the surface to dry thoroughly.

When sketching and drawing with pastels, but not layering colors, I find Daler Ingres pastel paper to be a good surface. Offered by Daler-Rowney in spiral-bound pads, these papers have beautiful, subtle colors. For a free, loose application of pastel with a soft-edged look, the Larroque Bergerac handmade papers by Sennelier are exciting to work on, and they come in colors designed to complement pastels.

STAINED PAPERS *shown: on the right, buff-colored Ersta paper as purchased, and stained; on the left, Wallis paper, white, stained, and with pastel colors turped into the surface.*

Small Surfaces for Location Studies

When I want to work on sanded paper for studies, first I have a sheet dry mounted onto plywood with a meltable plastic barrier called Fusion 400 between the paper and the board. Then I have this surface cut into shapes and small sizes (5 × 5", 5 × 7", 5 × 9"). I take several formats each time I go out to paint. Having a sturdy surface to work on makes it possible to travel without a cumbersome drawing board. In case of rain, a piece of glassine paper between two painted, face-to-face boards held firmly together with a strong rubber band works just fine.

Blending Tools and Fixative

A tortillon is a hard, rolled-paper cylinder, the point of which is used to spread or blend pastel; a blending stump, also made of rolled paper, has a shorter point, but is used for the same purpose.

If your work has a tendency to become muddy because many layers are superimposed, you can apply a light spray of fixative between some layers and then work again when the fixative is dry. A final spray or spraying

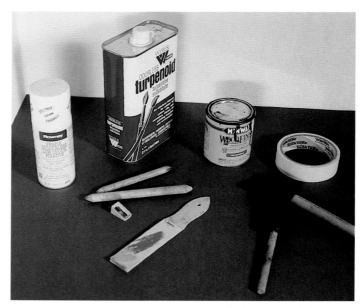

SOME USEFUL STUDIO SUPPLIES *include stain, polyfoam brushes, tortillons, Turpenoid (an odorless turpentine substitute), sharpener, masking tape, sanding block, and fixative.*

SURFACES FOR FIELD PAINTING *may be cut to size. These are the small surfaces I use for field studies. Other ready-made durable panels are available.*

your next-to-last layer of pastel with fixative is also helpful when paintings will be in transit, or when pastel paintings will remain unframed for a while and without the protection of glass.

Framing

Having had two large collies with bushy tails, and limited studio space, I tend to frame my work soon after it is completed—and in my haste, I usually forget to add my signature. But my accommodating framer has devised a way for me to remove my work easily from its frame and reinsert it again by using tab-screws that can be turned, instead of brads. In this way, my work is protected, yet I have the opportunity to make slight, final adjustments after unhurried and objective observation. This is an important part of my work process, sometimes taking months before enough detachment from a painting enables me to make dispassionate judgments about adding final touches.

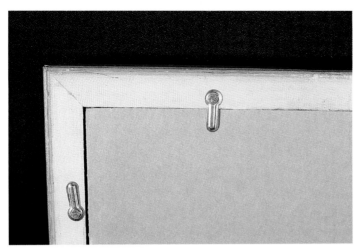

TAB SCREWS *can be turned aside for removal of work from its frame.*

MATBOARD SPACERS *glued to the back of a mat will help keep the mat free from pastel dust.*

Field Box

The "field box" is my name for an old berry-picking carrier that a friend and I found very useful many years ago when painting outdoors. I continue to use it simply because I haven't found any better way to get my supplies to a local painting site. (Obviously, this box is only practical when going to locations by car.)

When I set out to paint nearby landscape, all the supplies I need are in my field box and backpack. The latter holds moist towelettes, some small, sturdy painting surfaces, a folding seat, insect-repellent, sunscreen, a small blanket, sometimes a sweater, and always a lunch. All my pastel supplies are in the field box, which has legs to raise it from damp ground; a removable cover protects supplies in case of rain. Compartments of the box separate pastel pencils from sticks, and groups colors: blues, purples; yellows, pinks, oranges; browns, siennas, ochres; greens; and neutrals. Another compartment holds scissors, tape, screwdriver, kneaded eraser, tortillons, Turpenoid in a small jar, polyfoam brush, sanding block, and small sharpener.

Students often seem intrigued by my quaint field box, but berry boxes of this type are difficult to locate now. However, what works for one artist doesn't necessarily work for another, and there are surely many other means of getting supplies to a nearby painting site if you're unable to find a field box just like mine.

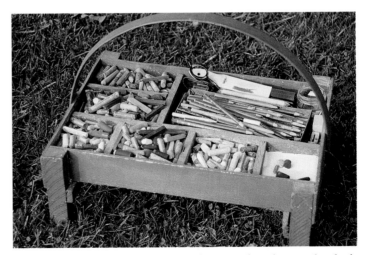

MY FIELD BOX *holds all the supplies I need to do near-finished work at a nearby site. Sturdy legs keep it off the ground, and under a removable cover my materials remain in usable order, so I don't have to set up each time I move to a new location. I use my field box when traveling to painting locations by car; it is not a practical option for trips by plane, train, or bus.*

NATURE JOURNAL

Keeping a nature journal can be a satisfying experience for anyone. For an artist whose chosen subject matter revolves around nature's changing landscape, keeping a journal is not only rewarding; it can be an invaluable source of discovery on a personal level.

It doesn't matter where you are geographically or how your seasons differ from those elsewhere. What is essential is that you tune in to what is happening around you in your setting, which, in turn, will enable you to draw from what you know best.

Each day, I take a break from what I am doing and enjoy a walk nearby, up the roads and paths I know well, or through the woods and fields close to my home. I'm gone only between twenty minutes and an hour, yet, I always notice some small change from the day before. When I return to my studio, I usually make a cup of tea and sit down quietly to write as little as a single sentence centered on the next blank page in my journal, and then date that entry.

Once in awhile, I make a sketch of something I've seen or brought indoors. Sometimes, I research a flower or a leaf in my guidebooks, but most often, I record just one observation. This quiet time has become a poignant ritual in my day. It constitutes "falling in love" with the day before me if I am out in the morning, or bidding farewell to the afternoon if I'm out later. At either time, it is a reminder of the joy that comes from learning about what nature has to offer when we take time to see deeply. I find that over the years, I see more and more in less and less. Some random sample journal entries look like this:

April 9: This morning I saw a single yellow violet near the stream that is now overrunning its banks.

June 22: The air is fragrant with the heavy scent of the catalpa blossoms which have begun their summer snowfall in the breeze.

September 11: For the past several days, the field of loosestrife has been at its peak, and the "purpleness" is breathtaking.

The purple of the loosestrife that took my breath away was transformed into a meadow of goldenrod only weeks later. Did it happen suddenly? No, but then nature doesn't wait for us to notice. It changes such a little bit each day, but with steadfast certainty and the power of a steamroller. Later, the loosestrife dulled with autumn rain, and the last of the purple disappeared with the summer butterflies. Meanwhile, the goldenrod had heightened inch by inch, forming yellow-green buds, and then familiar flower heads. Color increased until one day, it became overwhelming. The changing is continuous. When we happen to notice it depends upon how closely we pay attention.

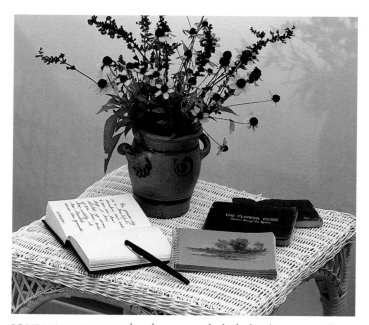

JOURNAL-KEEPING *has become a daily habit for me over a period of many years, and has evolved from extensive to joyously simple.*

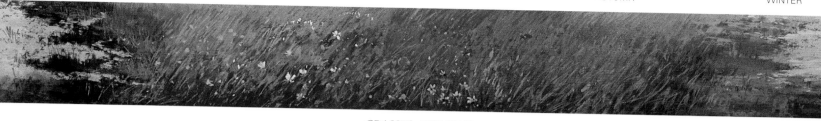

GRASSES, THE YEAR
Pastel on sanded board, 3¹/₂ × 30" (9 × 76 cm).

This earth study of grasses shows changes that occur as the year gradually progresses through twelve months in my area. Every section (of 2¹/₂" each) equals one month, until the yearly cycle completes itself.

LOOSESTRIFE, *a tall, common, invasive plant found in marshy areas, is scorned by farmers and sought out by artists for its rich color, as captured in this field sketch. As with Alaskan fireweed, it colors entire fields with purple.*

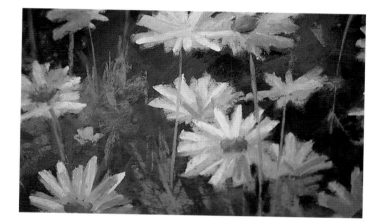

FIELD DAISIES AND QUEEN ANNE'S LACE, *shown in the above two studies, are common throughout much of the world in springtime and summer. They are easily recognizable and tend to grow in clumps wherever fields are unmowed.*

29

How Your Journal Can Help Your Painting

A journal is personal. By paying attention to nature's changes in your particular location, you can add a knowledgeable element of depth to your work.

Keeping a journal enables you to view the seasons as more than four separate, static divisions. When you have finished compiling an annual journal, you hold a record of daily changes that *you* have noticed. The concept of the year as a changing, evolving whole becomes significant. Consequently, you become adept at matching landscape components accurately with each season in your area when you wish to add something that is not at the scene where you are painting. For instance, if you wanted to paint some wildflowers in a field, by referring to your journal, you could add a flower variety that is appropriate for the time of year and region you are depicting. Even if you merely suggest flowers in your painting, it's better to suggest those that actually do bloom at that time. Otherwise, the distracting jolt of sensing something not quite as it should be makes it less possible for a knowledgeable viewer to appreciate the work. In a spring scene with apple trees in blossom, the dandelion would be a better choice for a foreground flower than autumn's goldenrod.

As you continue to record your observations, you will begin to see the larger, consistent patterns of each season, as well as more specific variations. A deeper understanding of the progressions of seasonal change will result in more painterly work, because you will not have to rely on being at the scene every minute. You will learn to sketch the large shapes, make color notes, and then work with confidence in your studio.

Finally, once you have the information you need from a scene you are painting, it is helpful to turn away from it. By remaining at the scene too long, you may succumb to the temptation of filling space with unnecessary detail. If the painting can be improved with changes, you can make them objectively, later on. Leaving the scene before completion of your painting, or just turning toward a different direction, also allows more room for your personal expression to enter the work.

TIPS FOR KEEPING YOUR JOURNAL

- Savor and enjoy this endeavor rather than allow it to become a task.
- Use a blank book without predated pages. Date each entry as you go along. It is forgivable to skip days at a time.
- Be specific. Some discoveries may require more than one page.
- Focus on different elements each year.
- As you recognize something you have seen before, your mind will build upon it, your knowledge will compound, and you will begin to use what you learn with confidence.
- Make journal entries that revolve meaningfully around the work you are doing at the time. What we learn finds its way into what we do.
- When you paint nature's changes into your work, you will connect with others who have experienced the same discoveries about nature.

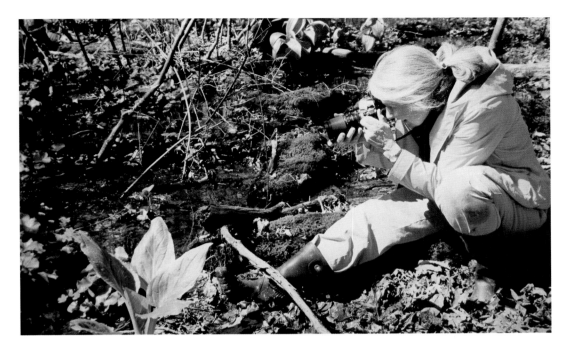

PHOTOGRAPHING WILD-FLOWERS. *No need to pick them—and a site such as this might not be the most practical place to do a painting. (Photograph by Albert J. Novak)*

TREES, THE YEAR

Pastel on sanded board, 5 × 15" (13 × 38 cm).

From left to right, this playful exercise is a horizontal calendar that shows changes that occur in trees throughout the year.

USING YOUR CAMERA AS A TOOL

Painting at an inspiring location on a beautiful day is what artists dream about, but ideal conditions are not always possible. Among other things, rain, chill, wind, or distance may prevent plein-air painting. But having a file of photographs allows you to compose and paint landscapes regularly, weather permitting or not.

By its nature, the camera lens is an easy-to-use viewfinder, especially outdoors, because it effectively eliminates distraction by blocking out everything beyond what you see through the lens opening.

With your camera, you can even purposely put your scene out of focus in order to see the large shapes clearly, without the distraction of detail.

You will soon find that the qualities that make an excellent nature photo are not necessarily the same ones that make a good painting. Nature photographers look for detail and contrasts. Painters use contrasts as well, in value, edges, color, and shapes, but the most painterly work is also the result of an artist's eye for balancing contrast with soft edges and subtle color.

Always avoid using photographs that someone else has taken. Since they don't represent your own experience, they lack personal connection. When you use photos *you* have taken as just one source of reference for your paintings, or to jog your memory of a sense of place, you are using your camera as a tool, rather than a crutch.

TIPS FOR USING YOUR CAMERA

- As you evaluate your camera view, ask yourself:
- Am I after the large vista here, or do I want to zero in only on a small part of the scene?
- Does a horizontal format suit this subject—or would vertical be more interesting?
- For this scene, do I prefer a low horizon—or a very high one?
- Are the negative spaces in this landscape scene pleasing?
- Compositionally, is the main object too central? Or is the view too symmetrical?
- Does my eye follow a strong line in the landscape, such as the slope of a hill, then go out of the picture—or does a landscape line go to the corner and become trapped?
- Finally, ask yourself: "Does this make sense?"

Keeping a Photo File

I use file boxes (5 × 7 × 15") to store my reference photographs. They easily accommodate standard 3 × 5" and 4 × 6" prints, grouped by subject matter such as clouds, fences, outbuildings, barns, fields, and so on. Each picture is dated, to tell me what time of year it was taken.

Suppose that it's wintertime and I'm working on a summer landscape in my studio and decide on a foreground of daisies. Under "Wildflowers," in a section devoted to daisies, I find a photo showing distant daisies in a field, illustrating how they grow in clumps. Another shows close-up daisies with some in shadow. In still another, it becomes clear which other wildflowers bloom at the same time, so those could be added to my painting as well, if I chose to do so. I even have a picture of drooping daisies in the rain. All were photographed casually and enjoyably over a period of time, then filed away.

Building a file is helpful, but the main purpose is to point my attention to a specific landscape component. My file is a priceless source of information simply because it is of sites and subjects that I have personally seen. Browsing through these files evokes memories of places I've visited, and that also influences my work, whether or not I refer to the photos as I paint.

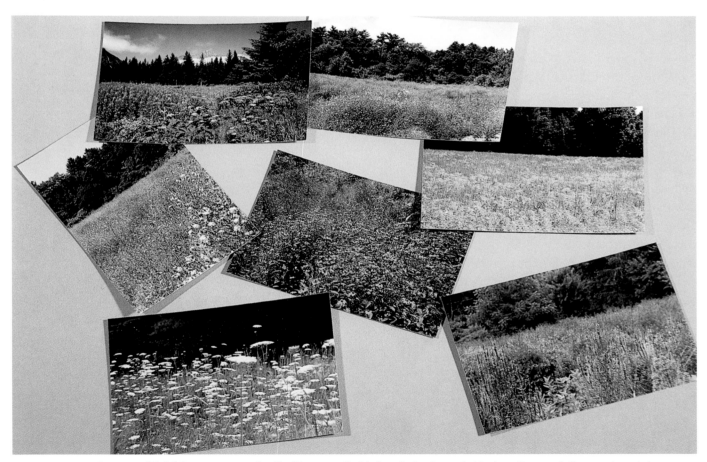

FILE PHOTOS *from my "Fields" section, specifically "Summer Fields," include shots of Alaskan fireweed, Queen Anne's lace, common loosestrife, goldenrod, ironweed, and black-eyed Susans. These are useful in reminding me of the intense visual impact of summer wildflowers en masse.*

COLOR STUDIES

Making a color study is a no-nonsense method of quickly getting a lot of valuable information into a small format. I use soft pastels for broad areas, then finish with pastel pencils. When a color study is not successful, I can brush it out and use the surface again, without having invested a great deal of time or materials. A study is exactly what the word implies: a place for learning through experimentation and risk. Taking the time to do small color studies helps to keep each idea about a place separate. The larger paintings that result from such studies will retain their strength and freshness.

There are several ways to use color studies. For example, when your intention is to stick closely to reality as you paint on location, your color study can record actual patterns of light and shadow before they change. The study also becomes a quick, accurate reference for both color and values if you must retreat indoors because of time or weather. This is equally important when you visit many beautiful locations during travel workshops, but spend only a brief time at each one.

Color studies are also useful when you intend your re-creation of the scene to be different from reality. For instance, you may want to use the composition of a favorite scene, but wish to change the color, time of day, or weather. For the advanced pastelist who has been observing nature closely for some time, this second method of using color studies is an exciting way to express and record separately many ideas that you may have about the same place.

Color Studies Help Maintain Focus

Once you abandon the color reality of a scene, then what? There are so many possibilities. You will be faced with the challenge of deciding on one of many interpretations. You can work out individual studies of the same scene, then evaluate them. This will help with the decisions about which ideas you wish to pursue in more extensive works, and your larger paintings will retain their focus. Otherwise, when more than one good idea is calling for attention as you begin a pastel, you might be tempted to use part of one idea, part of another, and so on. Sometimes when this happens, you discover that you have invested precious time and scattered energy into not only a "muddy" concept, but an overworked "muddy" pastel painting as well.

I find that my work is more powerful if I pursue a single idea of clarity and strength. Setting up and evaluating small color studies side by side makes it easier for me to decide which idea I wish to elaborate upon in a more ambitious painting. This type of visual sorting out can be direct and objective. It helps me keep my full-scale paintings clean and fresh, which, in my view, is a very desirable attribute of finished pastel paintings.

An additional bonus that sometimes goes along with making color studies is that you have miniature reminders of the special places you have painted and loved long after your work is owned by someone else. And, based on your studies, possibilities remain for future explorations of seasonal changes at a favorite scene.

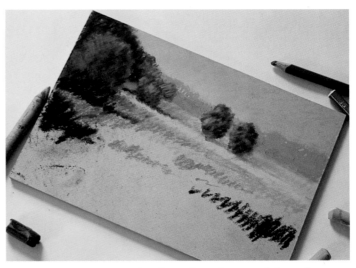

PENCIL SKETCHES *help us to see values. With correct values, any color palette is possible.*

SOFT PASTELS *are used to begin broad areas of this color study; pastel pencils will be used to finish it.*

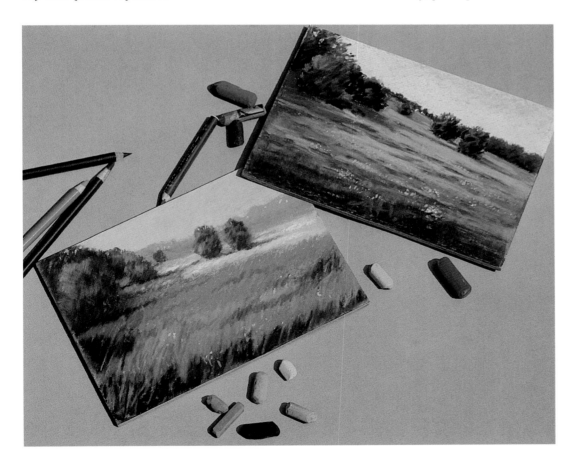

REVIEWING COLOR STUDIES *back in my studio, but still under the spell of a beautiful place, I study my two spontaneous versions. Working out color on a small scale helps keep my larger pastel paintings clean. Once I had decided to use the study on the left for a more extensive work, my mind was free to let the mood of the other one go, knowing that having the study, I could use it at another time (which I did).*

DEMONSTRATION: *Painting from a Color Study for Unified Color*

I know this meadow well. In all seasons, I have hiked up the far hill, through wild strawberry, summer nettle, slippery mud, and snow. By painting from my color study, away from the detail of reality, I can use the form and the light of nature, and then add a sense of personal mood and color to my interpretation.

I wanted to draw the viewer into and through the field, up the hill in the background, to the stand of trees at the top. This part of the scene is as important to me as it is small and subtle.

Because the undulating contours of the meadow in this scene would have been lost in overhead light, I chose morning to do the sketches and studies. As the sun rose at the left, shadows gave shape and compositional strength to the simplicity of the field. The interplay of cool shadows and the warmth of dried grasses set up a rhythmic horizontal movement that took on additional momentum as it moved from the middle of the field into the foreground.

Preparatory steps for paintings vary according to the subject and intent. In this painting, color decisions for the large areas were already worked out in my study. I spent the time I needed to establish subtle color relationships in the background, which set the tone, then I related all stroke, color, and value to that small area. This is one of the ways to achieve a harmonious effect in a painting. I saved details for last, and found that I needed very few. Blue and purples that were chicory and ironweed to me, could be lupine or clover to someone in Maine or Alaska or Texas. Working from color studies takes you away from specifics. The point is that in some paintings where the landscape is of a nonspecific nature, suggestion is more powerful than detail.

FOUR SEASONS *of color studies for* The Meadow, *each with its own distinct seasonal energy.*

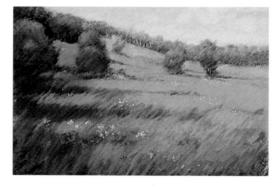

STEP 1: ESTABLISHING LARGE VALUE MASSES. *After a minimal sketch on my sanded ground, I place my first layer of color with soft pastels, using open, diagonal strokes. As in my color study, the sky sets a tone for the summer haze effect I want in the background. I apply cool purple and green soft pastels in open strokes to shadow areas, and warm ochre soft pastels to the sunlit pattern across the field. Attention to color distribution keeps this simple landscape quiet.*

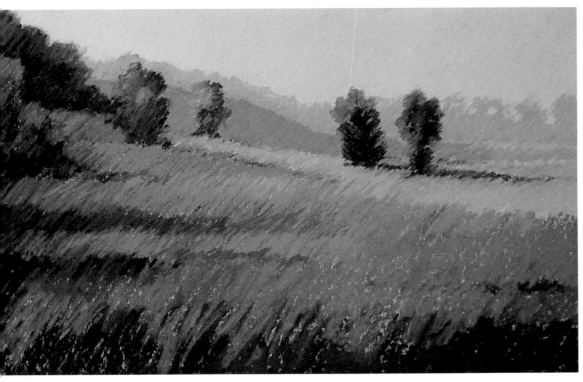

STEP 2: REFINING SHAPES. *To minimize texture in the sky, I close up strokes in that area with mauve and blue pastel. In the remainder of the painting, traces of the first layer of color show through subsequent layers. Soft pastel begins to fill the tooth of the paper. With deliberate strokes of warm and cool color, I shape the trees and shadows across the grasses.*

STEP 3: UNIFYING COLOR.
The field, having been prepared with color, is now ready to catch morning sun on its grasses, which I apply with a higher value of yellow pastel. Then, lightly scumbling a blue pastel pencil through the background hill, trees, and grasses, I harmonize the color and soften edges. As I approach the foreground, pencil is exchanged for several values of blue soft pastels, and heavier pressure is applied in some places, leaving more color behind than is possible with pencil. This step ties all colors together, giving the painting a sense of serenity.

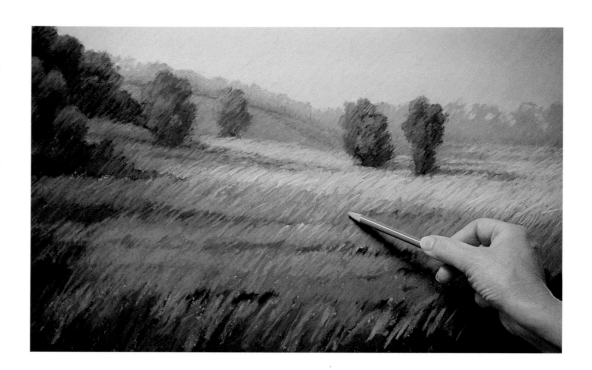

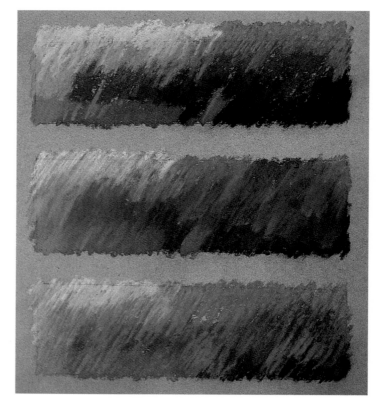

DETAIL. *These sketches magnify techniques used to unify color areas in* The Meadow *field grasses. To begin, three rectangles were covered with strokes of soft pastels on sanded paper:*
TOP: *Strokes made with soft pastels only.*
MIDDLE: *A blue pastel pencil is scumbled through the area in the same direction as the applied soft pastel. Hand movement should be rhythmic, with the pencil sometimes touching the paper, sometimes not.*
BOTTOM: *More blue soft pastel is used instead of pencil. Hand pressure can be varied, depending on desired effects. With practice, the pencil or soft pastel stick will become an extension of your hand and mind and do its own spontaneous dance upon the paper with interesting results.*

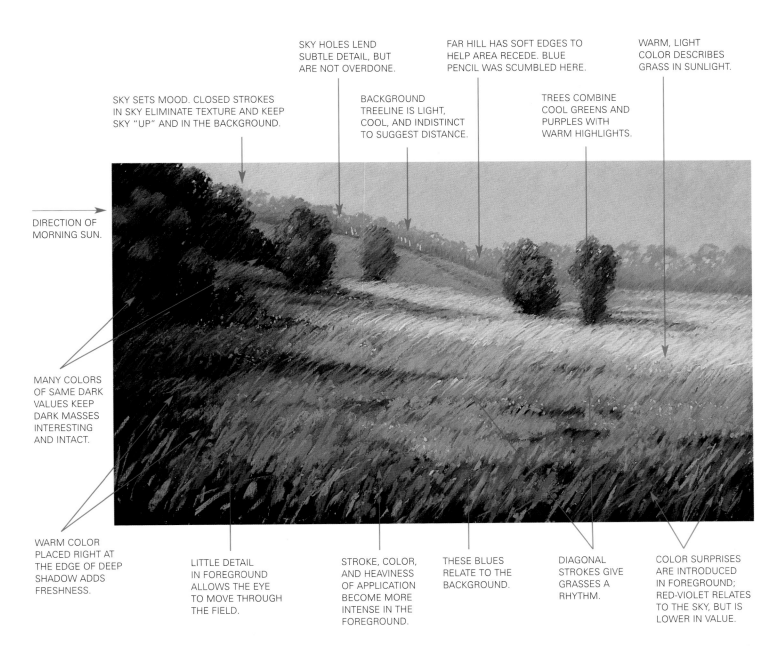

SKY SETS MOOD. CLOSED STROKES IN SKY ELIMINATE TEXTURE AND KEEP SKY "UP" AND IN THE BACKGROUND.

SKY HOLES LEND SUBTLE DETAIL, BUT ARE NOT OVERDONE.

FAR HILL HAS SOFT EDGES TO HELP AREA RECEDE. BLUE PENCIL WAS SCUMBLED HERE.

WARM, LIGHT COLOR DESCRIBES GRASS IN SUNLIGHT.

BACKGROUND TREELINE IS LIGHT, COOL, AND INDISTINCT TO SUGGEST DISTANCE.

TREES COMBINE COOL GREENS AND PURPLES WITH WARM HIGHLIGHTS.

DIRECTION OF MORNING SUN.

MANY COLORS OF SAME DARK VALUES KEEP DARK MASSES INTERESTING AND INTACT.

WARM COLOR PLACED RIGHT AT THE EDGE OF DEEP SHADOW ADDS FRESHNESS.

LITTLE DETAIL IN FOREGROUND ALLOWS THE EYE TO MOVE THROUGH THE FIELD.

STROKE, COLOR, AND HEAVINESS OF APPLICATION BECOME MORE INTENSE IN THE FOREGROUND.

THESE BLUES RELATE TO THE BACKGROUND.

DIAGONAL STROKES GIVE GRASSES A RHYTHM.

COLOR SURPRISES ARE INTRODUCED IN FOREGROUND; RED-VIOLET RELATES TO THE SKY, BUT IS LOWER IN VALUE.

THE MEADOW

Pastel on sanded paper, 12 × 20" (31 × 51 cm). Collection of Judith and John Missell.

STEP 4: FINAL DETAILS. *Now is the time for defining sky holes in background trees and details in foreground grasses. I use red-violet as well as some sienna as a color surprise in several foreground spots. Finally, I add delicate hints of field flowers such as blue chicory and abundant purple ironweed. Mood, paired with a simple landscape that has no distracting specifics, is an invitation to viewers to fill the space with their own thoughts and yearnings.*

39

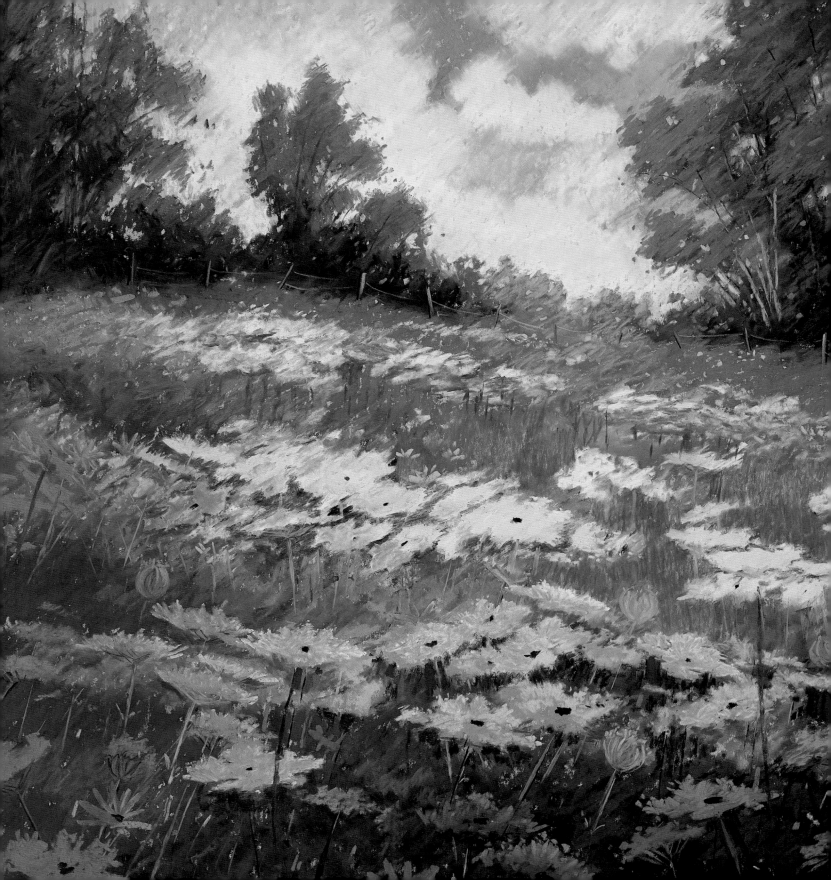

2
Spring

VERONICA'S LACE #1

Pastel on Wallis paper, 30 × 40" (76 × 101 cm). Collection of the artist.

This large painting was created in honor of my mother, Veronica, who loved Queen Anne's lace. While it leans toward a romantic interpretation of a field, the dialogue between the background and the simple palette chosen for the flowers gives the subject strength.

A RESPONSE TO SPRING

Out from under matted brown leaves, the first snow-drops and marsh marigolds herald the season. Spring is a new beginning, a good time to begin an acquaintance with nature, or rekindle an old one. At first, the seasonal changes take place gradually, and unlike the botanist, we are not required to classify or categorize what we find. Instead, we are free to sketch and paint outdoors whenever the weather permits, or simply to witness and absorb the onset of nature's evolving cycle. Sometimes ideas for paintings will occur; other times, they will elude us, only to show up later in the backgrounds and foregrounds of our work.

The first signs of spring can be noticed when you look downward at the wet, warming soil. The grass is greening, the tender skunk cabbage glistens in the wetlands, ferns uncurl, and the year's first flowers awaken. Brilliant reflections in the water collected by muddy pathways and roads strike jewel-like contrasts to the rain-soaked earth. Just above ground level, budding bushes and shrubs host returning birds that sing and call to one another even before dawn.

When you look off toward a wooded hillside, you will see florescence, the beginning of bloom that so delicately transforms winter's gray, deciduous tree line into warm pastel tints of green and pink, and the willow's yellow. Only a week or so later, leaf buds on trees burst dramatically into green, and you will see geese returning across the warming sky. By mid-May, warm air carries the heavy scent of flowers and grasses, and butterflies and insects add to the activity. Changes in form multiply. Cirrus clouds sweep the sky above us. Newly ploughed mounds of earth freshen the grayed fields, and winter's bare branches round out with blossoms. Notice how violets, bluebells, jack-in-the-pulpit, and trillium spread over the woodland floor—how lilacs and forsythia soften the expanse of weathered barnsides. Spring's optimism colors the landscape. Our paintings, too, fill with the color we have longed for.

D'AUNAY MORNING
Pastel on Wallis paper, 9 × 12" (23 × 31 cm).

This small study is a romantic interpretation of a rather ordinary composition. Sky color stays intact as the primary idea here, and other elements in the painting do not call out for attention. By doing small studies, you can try out many ideas and still retain clarity of focus, because you are using only one idea per painting.

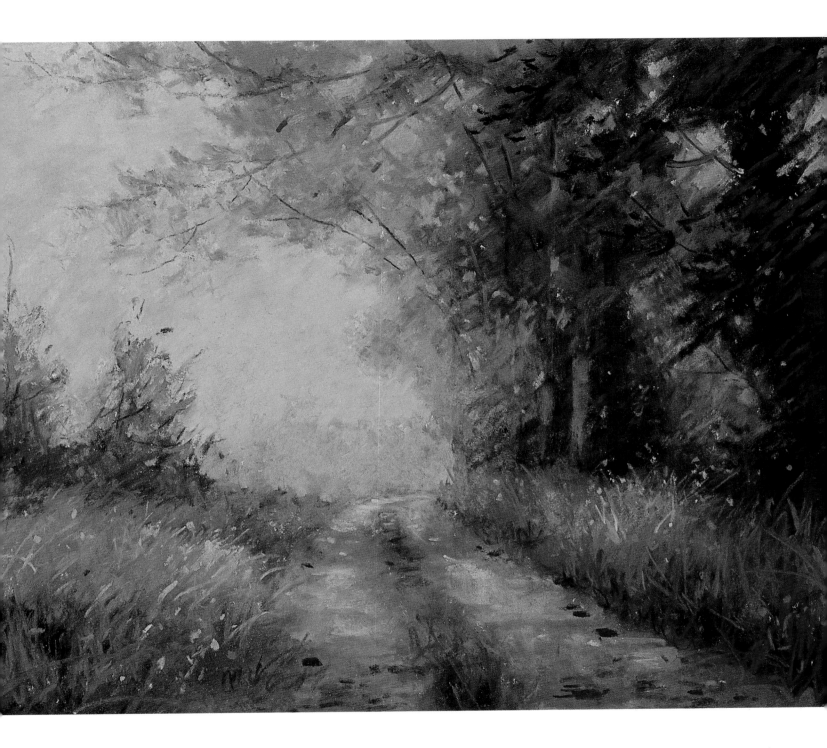

HINTS FOR BETTER SPRINGTIME PAINTINGS

Together with the landscape's saturation of new color, spring's multiplicity can be disquieting to the senses. Throughout the winter, you have looked deeply into the landscape, searching and pulling out what you needed for your paintings. Now the landscape is inundated with growth and color, necessitating a change of tactics. Instead of searching, you will engage in an intelligent sorting out.

Much of the time, weather now permits you to paint outdoors, where keeping focused becomes critical. Being literally surrounded by subject matter can be unsettling even to the advanced painter. If you are a novice, you may feel bewildered by foliage or a moving sky above you, the colorful growth beneath you, perhaps some water to your right, or a barn or orchard to your left. It is all there, all real, and it may all be interesting and paintable. The most difficult task is to choose a focal point and to make it important in your painting. Inability to do that will lessen your chances of painting a successful landscape even before you begin.

Using a Viewfinder

Making and then *using* a viewfinder can be most helpful in selecting a focal point. Instead of cutting a centered square from a piece of matboard for a viewfinder, discover the advantage of using two L-shaped pieces for the same purpose. Simply by moving the L-shapes, you can change the format of your view from horizontal to vertical to square as you look, until you decide which is most suitable for each subject you intend to paint.

Choosing a format for your selected subject matter means that you determine, with the help of your adjustable viewfinder, the shape of the picture you intend to paint based on where the center of interest will be within that shape, and how much of the scene you wish to include or exclude. As you gain experience using your materials to obtain the color and values you want in your pastel work,

you will give more thought to composition and format. Sometimes you may decide to paint the entire vista before you; other times, only a portion of a scene will appeal to you.

Always base format decisions on what will enhance your interpretation of the subject. Filling up space on standard-sized surfaces just because they are conveniently available is often counterproductive when you consider the end result.

If you must work from a photo, move your two L-shaped viewfinder pieces over the picture until you find the spot that interests you most—then use only that section of the scene as your subject matter.

Maintaining Strength in a Romantic Interpretation

Springtime beauty is everywhere. You may be captivated by the apple blossoms, the swaying daffodils, the blooming hawthorn, the budding maples—but if you try to put them all in one painting on the theory "If a little of a good thing works, then more will be even better," your painting might be unfocused from the start and you may never know what went wrong. Because one dessert topping would be delightful, will ten be better? Think about this when planning a painting. If you decide to use one type of flower in the foreground to complement your center of interest, will additional varieties of flowers improve it even more? Probably not.

Romantic interpretation of a landscape based on emotion must be accompanied by full awareness of your intentions, and then tempered by a reserved subtlety. When you intend to paint a romantic interpretation of a landscape, you must always take care that your emotion toward the subject is balanced by subtle technique. (This is sometimes difficult for beginners still trying to master their skills.) In this way, you use emotional input from the senses to add to your work rather than control it, which is what frequently happens when paintings become weak, unfocused, or saccharine.

VERTICAL. *Here, the two-piece viewfinder marks a vertical format on a photograph showing the path of a tumbling stream. By including the background's falling water, which is important to the "story" of the water movement, the falls in the middle ground appear to be crowding the edge on the left.*

SQUARE. *Moving the viewfinder into a square format improves the position of the waterfall in the middle ground, but there is still a lot of distracting water movement in the foreground.*

HORIZONTAL. *This format now puts more space on the sides of the subject and excludes the foreground distraction. The emphasis is now on the center of interest.*

THE SPRING PALETTE

Spring's explosion of color can be overwhelming. Nature's superiority is evident in riotous combinations that defy all complement. But remember, the whole world is nature's canvas. Even with color wheels and intensity charts, human beings fall short when attempting to put springtime's full panorama of color onto a two-dimensional surface.

Bits of color surprise show up wherever we look: the red-winged blackbird, the cheery crocus, and later, the speckled egg in a nest and the butterflies. Running water is picking up color from the new, young greens in grasses and the warming blue of the sky. Blossoming trees lace hillsides and orchards with white and pink.

Despite the return of color in the landscape, spring is a time of less obvious contrasts than other seasons.

Just after leaf buds open, there is a short period of time that is best noticed, appreciated, and then, in my opinion, dismissed as a source of subject matter. Although the qualities of balance that make a painting strong are present, they are difficult to find. For example, the predominant colors are pale and warm: pinks, cream, yellows, and yellow-greens. The soft edges of new growth create a temporary fuzziness. Large, solid shapes disappear under delicate foliage. Unless you are aware of these problematic spring conditions and then take compositional steps to resolve the imbalance, lack of contrasts in color, temperature, value, and edges may result in work that appears insubstantial, or even, in a pejorative sense, too pretty.

SKY

FLOWERS,
GRASSES,
AND SHRUBS

DISTANT
HILLS AND
MOUNTAINS

TREES

Achieving Harmony Within the Spring Palette

This is a season to be in awe of color and to use it with thoughtful respect. As we are confronted with pink, orange, yellow, scarlet, and fuschia, each showy and weighty, we realize that together, on a limited painting surface, they can be oppressive. Several approaches to handling spring color include: choosing one strong color to play a dominant role in your painting and subordinating the others by using them sparingly, as accents; and exploring fewer colors in greater depth by varying temperature and value. The possibilities of color expression without repetition are incredible with pastel, and you will have many other opportunities to use the colors you purposely choose to pass by today.

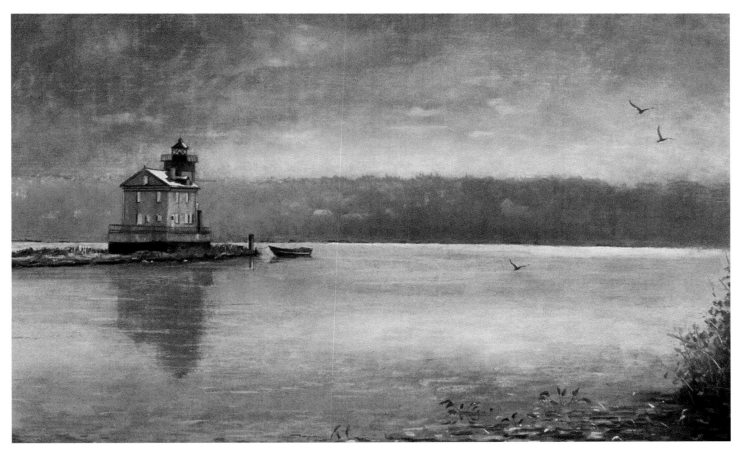

MORNING ON THE HUDSON

Pastel on Ersta sanded paper, 20 × 36" (51 × 92 cm). Collection of Key Bank.

In paintings of larger bodies of water, the level of water is less affected by changes of season, except during severe drought. However, different times of day and year do impart an atmospheric mood to places near water. Here, stillness and early light cast a placid mood over the river.

LEIGHTON ROAD

Pastel on Ersta sanded paper,
21 × 26" (54 × 66 cm).

This lupine-lined dirt road in Pembroke, Maine, disappears from view before it ends at the bay. Colors here work together toward a quiet harmony, achieved by using many values of fewer colors. Note how warm and cool greens convey the temperature variation between sunlit and shadowed areas. Distance is shown by light values, smaller shapes, and softer edges. Foreground detail remains quiet and does not detain the eye from moving along the road toward the horizon.

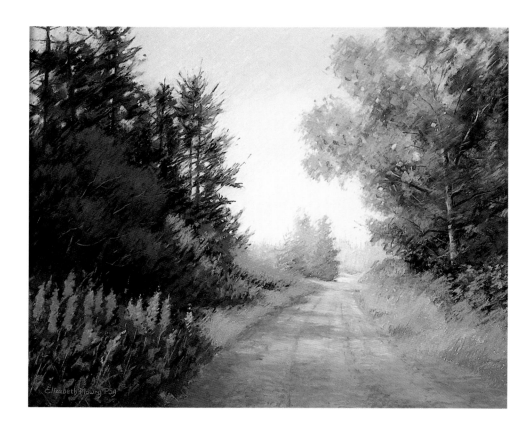

ANDRÉE'S COW

Pastel on Sennelier La Carte,
8 × 12" (20 × 31 cm).

The center of interest here is the actual center of the composition, but my asymmetrical placement of trees on different planes makes the painting work. (This is an excellent learning exercise: Place your focal point at the center of your painting surface and find out what you must do to get the composition to work.)

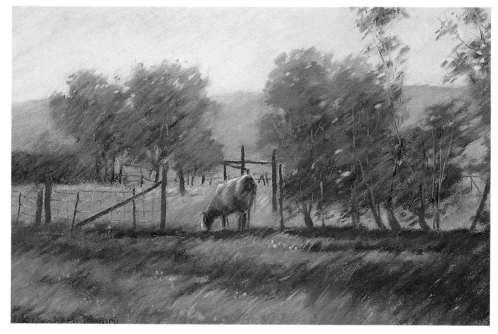

AFTER THE ICE, THE RUNNING WATER

When spring rains add to melted ice and snow, small streams tumble down even the slightest slope and often overflow their banks. When I visit the same painting site week after week as the season progresses, I find the shapes of moving, falling water to be different all the time, changed by rising and lowering water levels that vary by even as little as a half inch. For instance, when the water level decreases even slightly, what may have been one solid fall of white water will now be divided into two narrower falls by a rock that wasn't visible a week earlier. Multiply this by fifteen other rocks that also emerge when the water level drops, and I find a painting scene that is substantially different from the one I worked on previously at that site.

When painting a scene that includes rocks and running or falling water, you should save all areas of high (light) value water for a few pristine passes of pastel at the very end. This means that the first layers of pastel in your painting of running water will not include the light value of the falling water for reference. Since you are constantly adjusting color and value as you work, just remember that after you do add the lightest colors in the water, you will want to evaluate all color and value relationships again before making final adjustments.

Down a gradual slope, water gurgles and waltzes gently over the rocks, whereas when the incline is greater, it will crash and splash into a livelier dance. Yet later in summer, the very same stream may be completely dry. The rocks over which water flows have to make sense, just as the drapery over a figure has to make sense. The position of the rocks determines the water's course over a streambed. Whether water parts around a high rock, trickles over a flat one, or crashes down a pile of rocks depends upon the height of the rocks, the depth of the streambed, and the water level on the day you are painting it. Your paintings of running water will improve when you pay attention to these considerations as you paint.

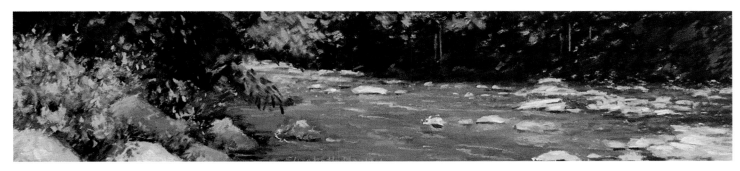

VERMONT STREAM

Pastel on sanded board, 3¹/₂ × 15" (9 × 38 cm).

Collection of Annie and Randy Ross.

This small, on-site study gives an idea of what kind of information to record when you are outdoors. Note how the streambed gets warmer at the far edge of the water and at the right corner, where the water is shallow. Visible rocks and pebbles will frequently tell you where those areas are.

Although you do not need many pastels for a small study such as Vermont Stream, *you can see that a full value range was used.*

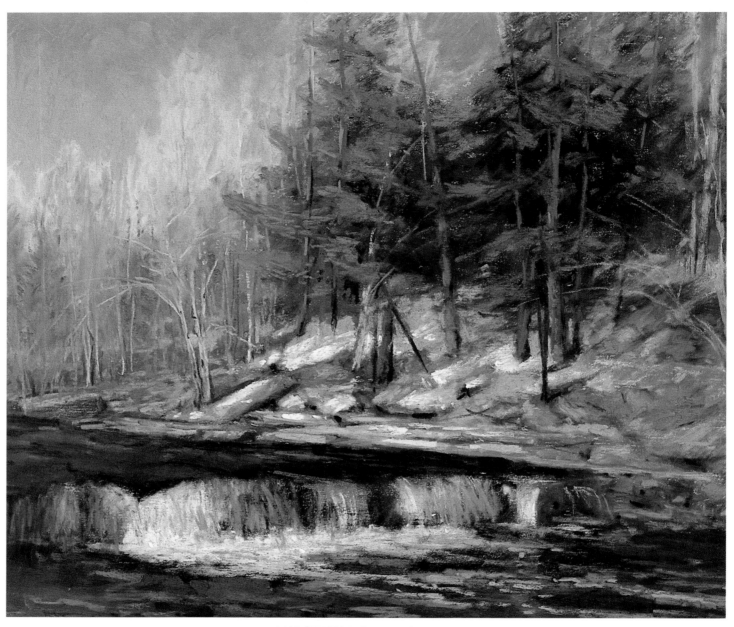

MARCH THAW ON THE SAWKILL

Pastel on Wallis paper, 12 × 12" (31 × 31 cm).

Here, melting snow contributes to a high water level, covering many rocks that are visible in other seasons. Lingering snow in the shadows of the trees will soon disappear.

DEMONSTRATION: *Painting Running Water in a Stream*

Painting running water in pastel is not difficult if you begin by using a viewfinder to limit the scope of your composition to parts that interest you most. Be sure to give your center of interest enough space to make it important, then begin blocking in as many large shapes and planes as you can find. Squinting helps eliminate details at first, but when blocking in rocks, refrain from generalizing their shapes. "Made-up" rocks lack the important planes that give them weight and solidity.

In establishing a streambed over which the water flow appears natural, in the lightest areas, except for merely suggesting dark rocks underneath, leave the surface untouched until late in the painting. Often, palest blue, pink, or green tints are more effective than white for painting highlights on running water. Use the lightest touch possible for highlighted rushing water, allowing your paper texture to impart freshness and sparkle. Evaluate after each stroke, and perhaps add a few splash dots, but sparingly. Finally, add desired detail if it helps your painting, but pass it by if it does not.

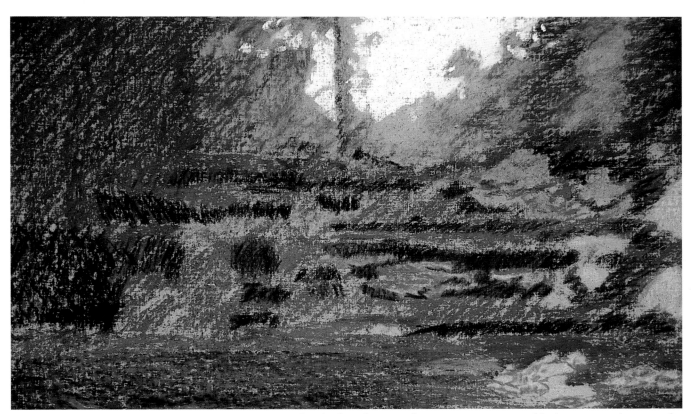

STEP 1: GETTING THE LARGE SHAPES DOWN. *After finding the view that interests you most, block in major shapes with a first layer of soft pastel on a medium to dark pastel surface. Where running water will occur, barely touch that area with dark color—such as deep violet or dark green—to suggest the rocks underneath. No water yet!*

STEP 2: SETTING THE SCENE. *Blend the sky with closed strokes. Shape the foliage and indicate major tree trunks. Then spend some time pulling out some rock shapes. You are preparing the streambed for the water here. Don't be concerned that your surface is unevenly covered with pastel.*

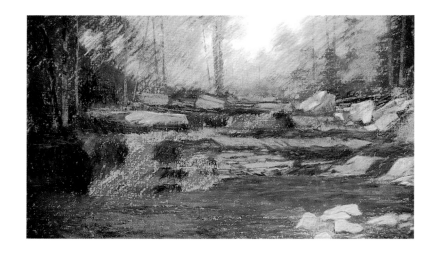

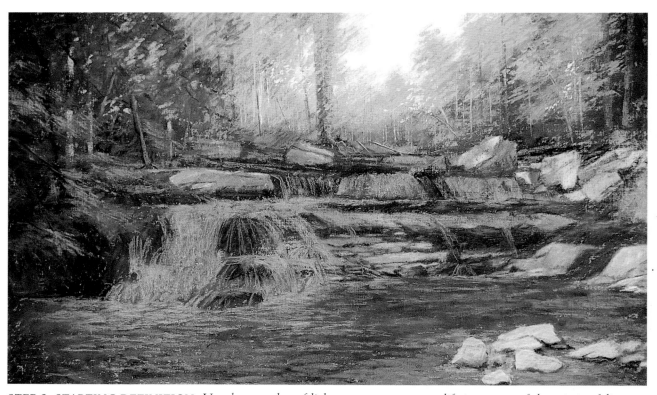

STEP 3: STARTING DEFINITION. *Use short strokes of light, young green to put life into parts of the existing foliage patterns closest to the source of light. In some places, such as on the left here, keep areas of dense shadow intact; they will complement the center of interest rather than fight with it later. Start to put some rich colors—greens, purples, indigo—into your water, going warmer with sienna and raw umber where rocks indicate shallow spots. Then with hard pastel, so that you do not fill the tooth of the paper, determine the pattern of the water's flow.*

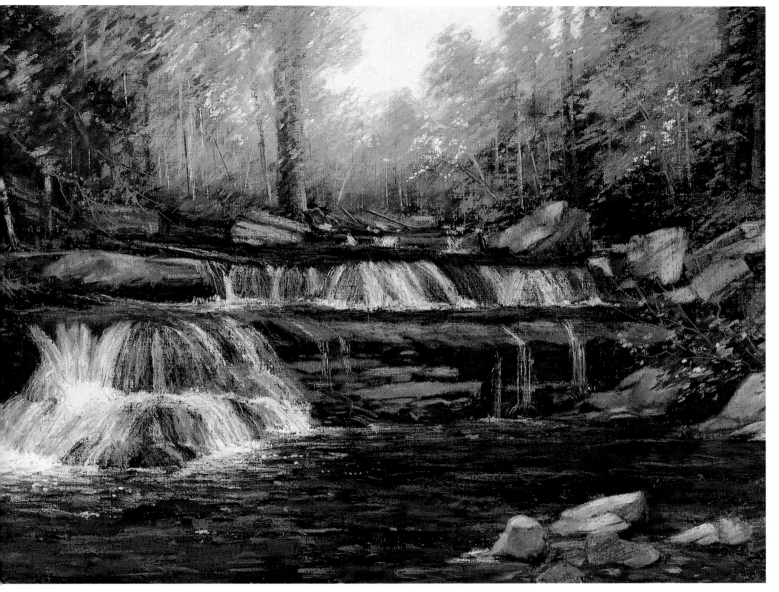

WOODLAND MUSIC

Pastel on sanded paper, 12 × 20" (31 × 51 cm). Collection of Renno and Nora Budziak.

STEP 4: LETTING THE WATER FLOW. *Use a high-value color tint as well as traces of olive green and blue-green to run water over the rocks with carefully placed, delicate strokes. Evaluate after each stroke. Then, based on the completion of your value range, make final adjustments. For example: Add some color into any dead areas without changing value; put directional movement strokes into the water; highlight a few rocks with warm sunlight, using rosy ochres; and add secondary foliage detail and branches.*

53

ZEROING IN ON SPRING

Beginning pastelists may find it beneficial to do some studies of single landscape components. A painting of a single flower will reinforce skills having to do with placement on the surface, varying strokes for effect, use of color and value for balance, and background treatment that resists overpowering or competing with the focal point. Honing your skills in single-component studies will enhance your work as you enlarge the scope of your paintings, and because studies are less precious, you will be more inclined to take the risks needed to learn new techniques. If your study fails, you can dismiss it, knowing that time spent learning is never wasted, and the small surface you worked on is dispensable. And sometimes—you will surprise yourself with a remarkably spontaneous study that merits a place among your best works!

DOORWAY, SPRING

Pastel on Ersta sanded paper,
9 × 8" (23 × 20 cm). Private collection.

Sometimes you will find that the feeling for place can be conveyed more poignantly by portraying a small portion of the subject than by trying to show it in its entirety. Here, the open doorway, enhanced by the delicacy of flowers, invites speculation as to what is inside.

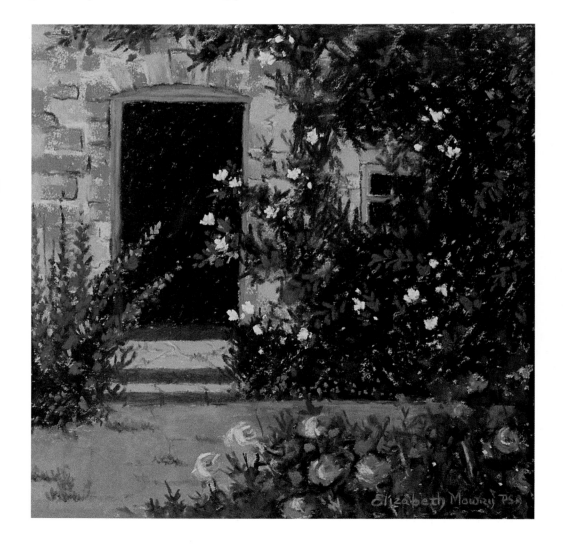

Using Close-up Studies to Solve Painting Problems

Zero in if you are having difficulty capturing the essence of some component in nature. For instance, if rocks in your streambeds all look alike, zero in on rocks. Take a close-up look at planes and shadows on each. Do small group portraits of rocks. After just a few studies directed at that small portion of nature, you will find yourself painting rocks in your full-scale paintings with much more understanding and skill.

Suppose the flowers you paint always seem to have a lollipop look. Zero in on flowers. Are the leaves stiff or graceful? Check the width of stems (often they are painted too wide and disproportionate to the flower). Look for and use repeated angles and shapes in blossoms and buds to capture the essence of the flower you are painting. (In Chapter 3, see "Painting Flowers Where They Grow.") You don't need an instructor for this kind of learning. Just take time to paint what you see, carefully.

POPPY CONFIGURATION (detail)
Pastel on La Carte Pastel,
9 × 7" (23 × 18 cm).
Private collection.

This detail focuses on loose strokes, unrefined shapes, and lots of surface showing through.

DEMONSTRATION: *Focusing on a Single Flower*

During a summer workshop, I did this sketch of a white peony. By limiting my focus to one blossom, I tried to show students how to paint white flowers that do not resemble cotton balls. Putting your undivided attention on something as singular as a flower prods you into deeper levels of perception. In this case, slightly exaggerating shadow shapes within the petals helped to form the distinctive appearance of the peony.

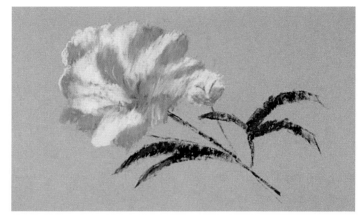

White flowers can be difficult to portray. Once you find darker areas within the whiteness, exaggerate them slightly to pull out the planes that are distinctive to the flower being depicted.

THE PEONY
Pastel on sanded paper, 5 × 9¹/₂" (13 × 24 cm).

By using side strokes of same-value colors around the flower with just a few darks and lights to suggest leaves and buds vaguely, you can transform a drawing into a painting. Color changes are subtle, and they add rather than detract from the focal point. Notice how a slightly deeper background makes the flower appear whiter; how background subtleties can coexist with definition at the center of interest; at how the background moves in to define flower edges and suggest dimension.

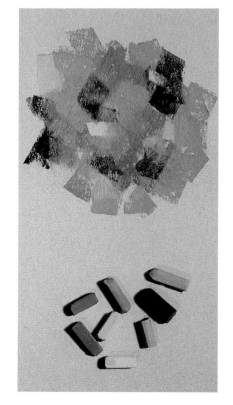

Here's the side-stroke treatment used for background in The Peony. *Don't hesitate to break your pastels into pieces to get the effect you want. Strokes made with half-inch pieces of soft and hard pastels stay fresh and distinctive because there is no blending. Pastel-pencil strokes of a single color applied throughout will pull the colors together even more.*

PAINTING THE LUSH GROWTH OF SPRING

By late spring, landscape becomes a proliferation of color, activity, sound, and scent. Bare trees that opened vistas of great distance have been transformed by foliage that obstructs the same views. If you attempt to portray nature exactly as it exists, you may even begin to find that too much reality can be a disappointment.

Practice scanning a scene and trusting your eye to find which part is most important to you. In addition to limiting the scope of your subject matter, you may also want to limit the size of your painting surface. These variables are different for everyone. People who paint very quickly with broad aggressive strokes prefer a large surface and include more of the subject in their paintings. Others paint exquisite, jewel-like studies that cover smaller surfaces and include less. Personality, emerging from personal experiences, plays a major role in all that we do—and therefore, in what we create.

The Importance of Focus

Ask yourself, as I do, "What is the main idea I am conveying here? How much of this subject is essential for the mood or sense of place to be conveyed?" Next, make the distinction between the center of interest and all that is secondary. This is critical to a good landscape, especially during springtime's multiplicity of growth and detail. For example, while you will generally see and paint more detail in a foreground than in a background, even within foregrounds, much detail can be merely suggested, and your painting will be stronger because of it. Even though leaf formations are clear close up, your pastel will be far more painterly if you detail one or two and a few parts of some others, then only hint at the rest with appropriately shaped strokes that do not detain the eye. When the abundant shapes of spring's foliage, grasses, and flowers seem overwhelming, squinting may help you to combine some of them into larger shapes.

PATH IN MONET'S GARDEN
Pastel on Sennelier La Carte,
8 × 12" (20 × 31 cm).

Time limitations while you travel may force you to simplify even your small pastel paintings, such as this one, painted on location and later refined in my studio. When on location, put in large masses first, paying attention to color values, then refine as time allows.

MONET'S WATER GARDEN
Pastel on Sennelier La Carte, 8 × 12" (20 × 31 cm).

As with the work on the previous page, this was painted on location. When working outdoors, if details compromise your main idea, leave them out. The reality at each of these scenes provided much more detail than I included in the paintings.

DEMONSTRATION: *Simplifying Spring's Abundance*

Before you start painting, it will save you time if you work out some approximation of light and dark areas in your mind or in a value sketch. Think of this planning as your map. Just as in planning a trip, in painting, too, it helps to have an idea of where you want to go and how to get there. Keep your initial sketch minimal, putting in only large, approximate shapes. Avoid getting caught up in detail too early. Let the pace of your painting be fast at first as your pastels feel their way around the surface. Then slow down as you begin to pull out shapes and refine others, always carefully referring to your subject.

STEP 1: PREPARING PAPER. *With a polyfoam brush, I applied a wash of Turpenoid over dark green and indigo pastel on part of the surface of a buff sanded paper taped to a drawing board; then I allowed it to dry thoroughly. This gave me a dark surface without filling any tooth of the paper. Flowers that go over this dark area will stay clean.*

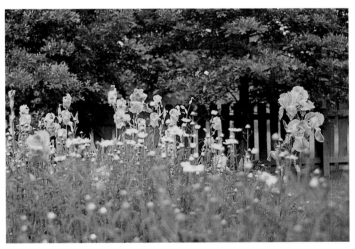

This photo shows more than I wanted to portray in a painting of irises and daisies, so I used the reality only to formulate the basic idea for my pastel—then later, as a source of reference in detailing the flowers.

STEP 2: ESTABLISHING SHAPES AND VALUES. *After blocking in the major flower shapes with approximate color, I covered the background with soft pastel, aiming for a gradual value transition from top to bottom and from left to right. Next, I added some blue and Naples yellow to the background, began to refine the iris shapes, then suggested daisies in the middle ground.*

SIMPLIFIED BACKGROUND, FROM
LIGHT AND WARM ON THE LEFT TO
DARK AND COOL ON THE RIGHT, DOES
NOT DETRACT FROM FLOWER SHAPES.

EMPHASIS GOES ON
THE IRIS THROUGH
ATTENTION TO
FORM AND DETAIL.

WHERE MANY DARK
SHAPES EXIST, I
PULL OUT JUST A
SELECTED FEW.

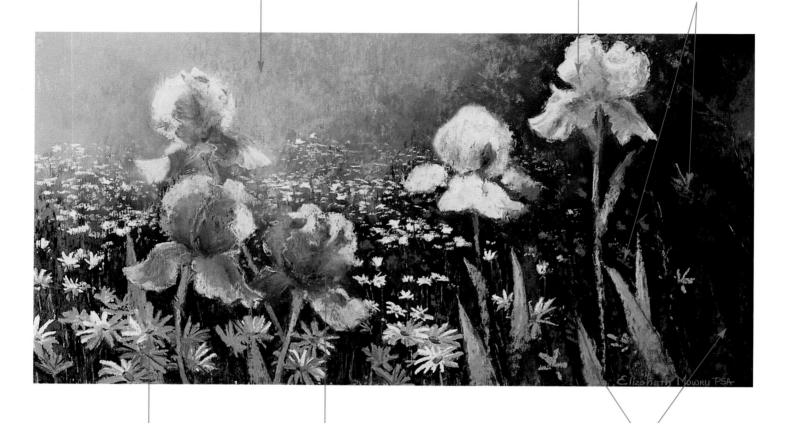

NEARER MASSED
DAISIES ARE LARGER
AND MORE DETAILED.

MIDDLE-GROUND STROKES
HINT AT A PROFUSION OF
FAR-OFF DAISIES.

TIPS OF A FEW IRIS
LEAVES ARE CLEAR;
OTHER LEAF SHAPES ARE
MERELY SUGGESTED.

IRIS AND DAISIES
Pastel on sanded board, 11 × 21" (28 × 54 cm). Collection of Mr. and Mrs. Daniel Miller.

STEP 3: REFINING SHAPES AND COLORS. *I completed the flowers outdoors with the subject matter nearby for direct reference. Finally, back in the studio and after several weeks of casual evaluation, I made color and shape adjustments throughout.*

Style as a Means of Simplifying Reality

Simplifying subject matter means different things to different artists. How much you simplify subject matter by changing, combining, or eliminating, depends upon personal choice. Faithfulness to your preference—whether it is based on an art philosophy, your specific experience and skills, or an underlying idea—will result in your style. Personal style may develop quickly or over a long period of time, and it may change after a while or frequently—but no one can teach you your own style. Other artists can only teach you theirs. While you may learn much from instructors, as you observe their styles and assimilate the range of instruction you receive, you will begin taking risks and learning from your own work. Then, one day, people will start to recognize your art as distinctly yours. At that point, you will know that the elusive quality called style is evolving in your pastel paintings.

The next two floral works, each shown in full then in detail, illustrate two approaches to simplifying that represent distinct differences in painting style.

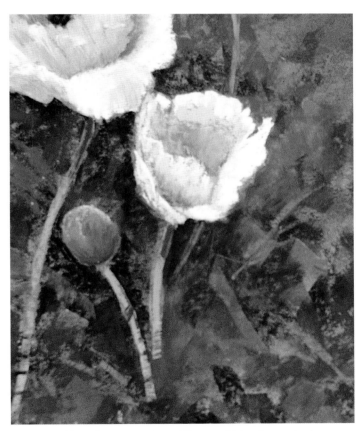

POPPY TRIO

Pastel on sanded paper, 16 × 17" (41 × 43 cm). Collection of Paul J. Pacini.

In this painting, the poppies are emphasized, while everything else is simplified. Dense growth is evident, but the poppies dominate because of size, color, and minimal background treatment.

DETAIL. *This close-up section of* Poppy Trio *shows the large, bold strokes, as well as a background that appears to fade away.*

DELPHINIUM SKY

Pastel on sanded board, 28 × 22" (71 × 56 cm).

Collection of Frank and Roberta Falatyn.

The approach here is selective detailing, mainly in the crinkly petals of the poppies. But stems and leaves are lost and found again without the viewer losing sight of what they are.

DETAIL. *This close-up look at* Delphinium Sky *shows the small, suggestive strokes that are left for the eye to blend.*

DEMONSTRATION: *Five Easy Steps to Painting a Flower*

When you wish to make a study of an unfamiliar flower or plant to place it in a painting, refer to it constantly as you work. Look for the distinguishing shapes and patterns of light and dark within those shapes. Even with species you know well, resist the temptation to paint from memory. Instead, scan each flower frequently to find its distinctive characteristics. Check out the tilt of the flower head, the bend of the stem, the formation of the bud or seed pod, the configuration of the leaf and its pattern of departure from the stem. Make size comparisons, check negative spaces, and, above all, put your full attention on the flower. Finally, once again I encourage you to lay in large shapes quickly when painting nature, then spend time refining. Always save details for last.

STEP 1: MIDDLE TONES. *Begin by putting middle tones into the flower shapes. For this poppy, I selected cadmium orange.*

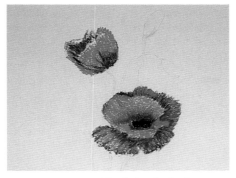

STEP 2: DARKS. *Find the darks by squinting at the real flower, noting where the darks fall, then work them into your pastel. The darks I used here are shades of burnt sienna plus a dark green.*

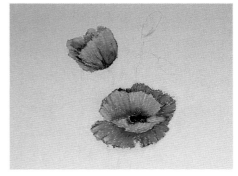

STEP 3: LIGHTS. *Now look for lights and highlights and stroke them in lightly with soft pastels. In this case, I used two lighter tints of orange.*

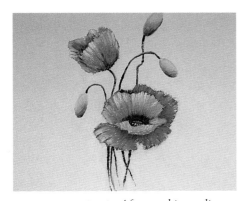

STEP 4: DETAILS. *After making adjustments in color and shape, add stems, buds, and more highlights. By painting them in last, a clean, objective placement can be coordinated with the larger shapes.*

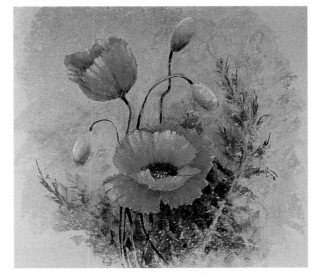

POPPY ESSENCE
Pastel on sanded paper,
13 × 14" (33 × 36 cm).

STEP 5: REFINING EDGES. *Use the background to shape the outside edges of the flowers. Side-stroke is an easy background to tuck around a sketch to transform it into a vignette. Taking the background to the edges of the surface will make it a painting.*

KEEPING MOUNTAINS IN THE DISTANCE

Knowing how to portray distance in your landscapes is an essential skill for pastel artists to master—and it is very easy to do so.

Distant hills and mountains often appear purple or blue. If the ones in your painting appear too close and you want to add distance to them, simply tone or crosshatch them with blue or purple, then soften any hard edges or lines.

EDGES ARE SOFTEST WHERE MOST DISTANT, PALE-BLUE MOUNTAINS MEET SKY.

ONE-COLOR, CLOUDLESS SKY KEEPS IT FROM COMPETING WITH OTHER ELEMENTS.

COLOR CHANGE TO PURPLE BRINGS NEARER MOUNTAINS CLOSER, BUT THE SOFT HUE TELLS US IT IS STILL MANY MILES AWAY.

FOREGROUND DETAILS ARE MINIMAL.

FENCE AND ROAD LEAD VIEWERS INTO THE CENTER OF THE PAINTING.

CONTRAST BEGINS WHERE TREES MEET THE FIELD. CONTRAST, DETAIL, AND STRONGER COLOR BRING OBJECTS NEARER.

SCOTTISH HIKER
Pastel on Ersta sanded paper, 15 × 37" (38 × 94 cm).

Hills and mountains appear distant when color and value change. In this vista painting, the blues and purples provide a subtle background for the old military road now used by hikers.

SPRING'S MORNING MIST

In early spring, particularly in areas where snow has melted or rain has fallen the night before, a lingering morning mist hovers over the landscape. This aura may also occur near a coastline or a large lake or river. For the perceptive artist, such a natural phenomenon throws a sense of unity over a scene, adding to a quite ordinary place a magical glow.

Each season's changes offer qualities that can enhance your paintings. In summer, watch for the blue or purple haze that softens backgrounds. In autumn and winter, crisp air will change the same landscape yet again. Always look for and be aware of the subtleties of each season that will keep your landscape paintings painterly.

THE EPTE
Pastel on Sennelier La Carte, 12 × 13" (31 × 33 cm).

I discovered Monet's blue morning mist in Normandy, France. Now I am able to recognize it in my own part of the world, even though the color and degree are quite different.

BRYAN'S WAY
Pastel on Wallis paper, 10 × 12" (25 × 31 cm).
Collection of Dr. and Mrs. Bryan Collier.

A morning mist softens the edges of everything in the background of this scene, adding to the mystery of what lies beyond the curve in the road. Slight changes in the value of colors you use next to one another will reduce contrast and make this happen. It is important to have an ample supply of color values when you strive for atmospheric effects.

3
Summer

VIEW OF THE RIVER (detail)
Pastel on Sennelier La Carte, 9 × 12" (23 × 31 cm).

In a scene where water comes right up to and across the foreground of your painting, you can use value and color changes to suggest the movement.

67

A RESPONSE TO SUMMER

At the height of full summer, the landscape is often quieter than in young spring or vibrant autumn. Growth reaches its apex, and wild grasses are ready to throw seed. Notice the softened edges of meadows as the tallest flowers bend and sway. Fields offer up many gifts for artists: Black-eyed Susans begin to appear; wild lupine, baby-blue bonnets, and chicory repeat their blues in ultramarine skies; stately orange lilies lend quiet elegance to lowly ditches and roadside banks; and blueberries smell sweet at the edge of the woods where animals feed in early morning and late afternoon.

Foregrounds are rich with mature color and definition, whereas backgrounds frequently recede into hazy, unfocused blueness. On hot summer mornings, crows call noisily across mown fields, where the pungent smell of seeds and hay hangs suspended in the dry air. Cows huddle together in the shade, tails switching. Near the garden, baskets of ripened tomatoes, rich in their redness, wait to be canned, and the scent of herbs is unmistakable. Even when no breeze moves foliage, the faint rumble of distant thunder can often be heard. Later in the day, you can watch shadows stretch and linger over landscape contours and then make patterns on fences and tree trunks before crossing and recrossing curving roads. By being mindful of changes that each summer day presents, and including them in your compositions, you use your keen perception as a vehicle for personal expression.

The grace that enriches all maturity is evident now in summer. Grasses bend low; flower stems, once straight and young, yield under summer showers; rounded cumulus clouds float overhead; and giant sunflowers bow under a brilliant sun. The boughs of fruit trees arch to the ground with the weight of maturing produce. Everywhere, stiffness gives way to curve. Use these graceful lines in your pastel paintings to design compositions of superb form. Each season has its own glory. Even now, as we paint the seed pods that have replaced springtime's buds, we know that they are tiny assurances of nature's continuance.

INVITATION
Pastel on Wallis paper, 9 × 12" (23 × 31 cm).

Here, a summer-shadowed road winds through tall grass and a few wild flowers. A small study such as this can capture the essence of an entire season and be as rewarding and meaningful as larger paintings. I continue to learn about nature and about painting from the many small studies that I do.

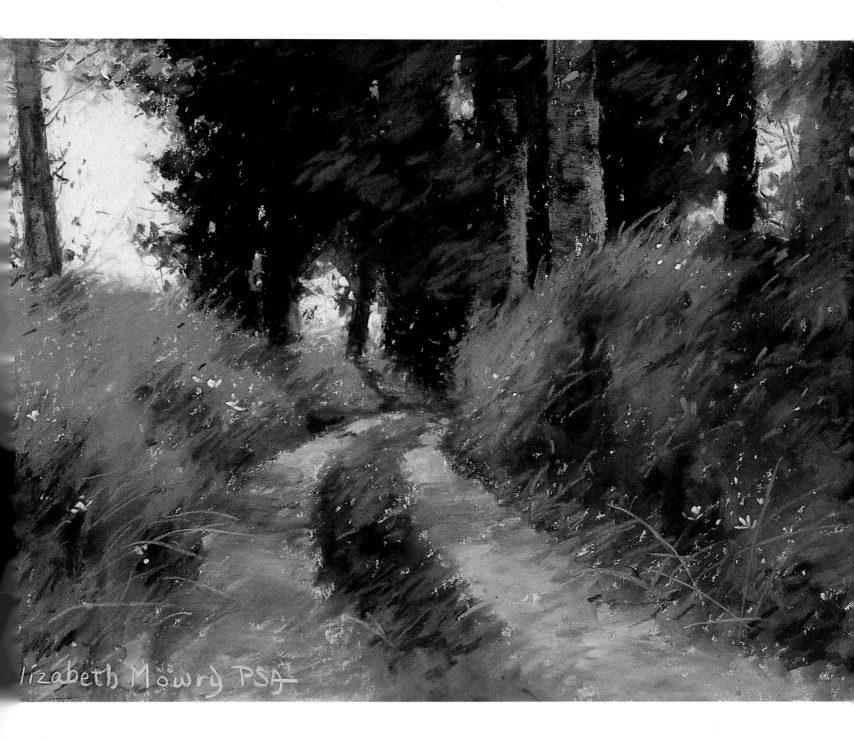

lizabeth Mowry PSA

HINTS FOR BETTER SUMMER PAINTINGS

In summer, foliage consists of millions of leaves that move and catch the light, making it difficult to sort out the large, massed shapes of trees and shrubs. But painting the leaves will not result in a painted tree. First, study the trees you intend to paint until you can find some of those large foliage groups. Squinting may help to eliminate smaller distracting shapes and details. Once you have put down large groups of foliage with a middle to dark value, be careful not to lose those shapes again by breaking them up with too many separated highlights.

Values

A keen working knowledge of values is essential to painting successful trees, shrubs—or anything else. Particularly as pastelists having hundreds of lush colors at our fingertips, we might remind ourselves that in spite of using many sticks of color in a given painting, an adequate range of values may still be lacking.

This outline of a catalpa tree helps me to find large foliage groups.

Close observation and some modeling make major shapes even clearer.

I once overheard an artist say, "I don't concern myself about value. If I have the color correct, the value will be correct." Although this holds true if your perception of color is faultless, and only if you are slavishly trying to copy nature, I believe that value relationships are paramount in my approach to painting. In searching for a personal interpretation of nature that differs from reality, I use color to express mood— so I must rely on value relationships in my paintings.

Values, simply put, are the lights and darks in your subject matter and in your painting. Relate them to one another. Consider not only whether an object appears light or dark, but how light or how dark it is compared with other elements in the scene. Ask yourself, "How dark are the shadows in that tree compared with the darkest part of the sky?" or "How light are the highlights on that tree compared with the lightest part of the water?" There are infinite degrees of light and dark. Trying to see in terms of black and white makes it easier to discern value. At first, when you look at a scene, try to find just three values: light, medium, and dark. After you can do that successfully, work with five values. If necessary, add more later. Until you see values in nature, you cannot expect to use them effectively in your paintings.

The Value Scale

To help strengthen your understanding of values, make yourself a nine-value scale like the one pictured here, which combines a white-to-black scale and a range of a few summer colors matched up to the value scale. If you fix this scale and tape it between two strips of acetate, it will be a handy reminder of value range to keep nearby while you paint.

Match Colors to Values

All colors have the same values as a simplified gray-value scale—and many more. When you put color next to gray on your scale and squint at it, it will blend with the gray if it is the same value.

Using the value scale is easy. For example, if you have a medium-green-value foliage group stroked in on a painted tree, refer to your scale to see how you might match up another green to a darker value on your scale and use it for the shadowy recesses in the tree. Then you might match up more greens to a lighter value for highlighted areas. Later, when you become accustomed to seeing colors as values in your subject matter, you can skip this entire exercise. Seeing and using value relationships will become second nature to you. Remember, first get a clear idea of the values you are looking at, then enjoy using any palette of color you wish.

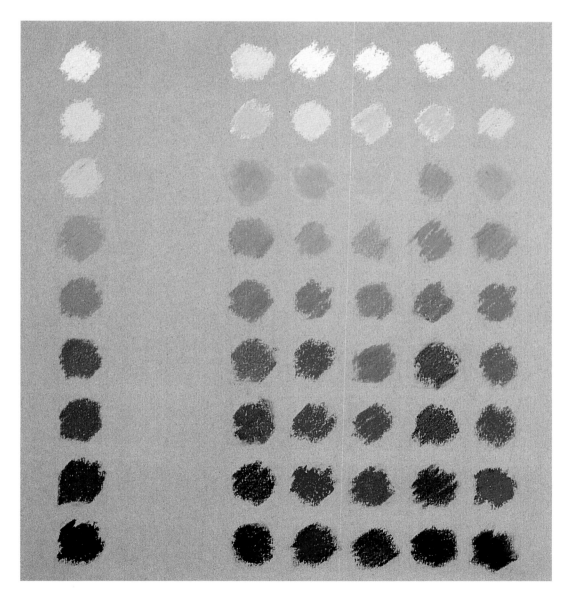

The column on the left shows nine values ranging from (#9) white or near-white at the top to (#1) black or near-black at the bottom. Place (#5), a medium gray in the middle; then (#3) a shade midway between #1 and #5; a midway tint (#7) goes between #5 and #9. Fill the remaining spots so that there is an even, gradual progression from #9 to #1. You may have to mix some grays, depending upon the number of pastels you have. Proceed in the same way to lay down values for the rows of summer colors, as shown, using your white-to-black scale as the value guide to be matched. Summer colors matched up to the value scale remind us of the wide range of value within each hue.

71

THE SUMMER PALETTE

At the height of summer, hills in the American West have been transformed to straw-colored contours that show off dark-green sprawling oaks. Deserts and canyons make their own kaleidoscopic magic under the bluest of skies. But in my northeast region, after blossoms disappear from trees and shrubs, and just as summer workshops begin and pastelists show up with hundreds of luscious new colors in tow, green is everywhere, dominating the landscape. For me, maturity as a painter and a growing preference for portraying "more in less" have transformed the all-green landscape from something I avoided whenever possible into an exciting challenge.

Making Greens Work for You

When variation in hue decreases, it is a good time to explore other properties of color such as value, temperature, and chroma. By juxtaposing cool and warm greens or high- and low-value greens, or intense and dull greens, you can bring shapes back into your paintings after summer's dense foliage and growth have confused them.

When painting summer landscapes, include lots of different greens in your pastel supplies. Single sticks of pastel are readily available. When adding greens to those you already have, go for variety in value. Having a broad value range will multiply the effects you can achieve in your paintings.

At first look, the greenness of a summer landscape may seem too monotone to portray interestingly. But if you take time to sort out the subtleties of greenness, your explorations will catapult you over the obstacle. To start, try adding some purple or indigo crosshatching into the deepest green areas. Within lighter green masses, cross-hatch some blue or ochre.

After you become comfortable using other colors within your painted greens, you will even begin to see minute traces of those colors when you look intently at the green landscape. Overstate those traces of color just enough to make your painting more lively but still believable enough for the viewer to relate to it. Sometimes you may choose to overdo for special effect. Be aware of your intentions as you move from reality toward fantasy.

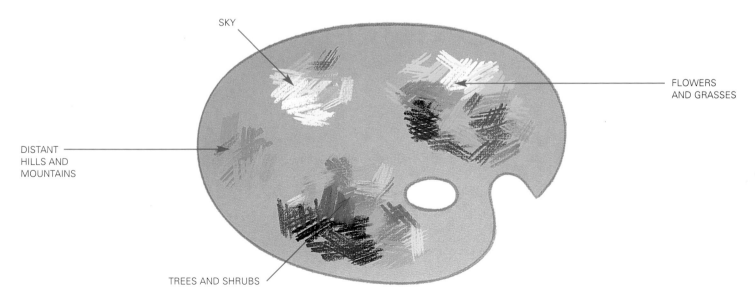

SKY

FLOWERS AND GRASSES

DISTANT HILLS AND MOUNTAINS

TREES AND SHRUBS

DEMONSTRATION: *Painting the Greens of Summer*

This demonstration shows how to approach the green landscape common in summer. It was my intention to convey the inviting expanse of an open meadow through a pleasing distribution of sunlight and shadow, using a primarily green palette.

RIGHT, STEP 1: HARD PASTELS. *Side-strokes are applied with hard pastels on a sanded surface, in this case, Wallis paper.*

BELOW, STEP 2: TURPENOID. *Using a polyfoam brush, I apply Turpenoid to light areas first, then dark. When the surface is completely dry, I add a few sketch lines, using a light-colored pastel pencil.*

RIGHT, STEP 3: SOFT PASTELS. *The first layers of soft pastel put color values into the major shapes of the composition.*

SUMMER PATH
Pastel on Wallis paper,
14 × 20" (36 × 51 cm).
Collection of the artist.

BELOW, STEP 4: ADJUSTMENTS. *Color temperatures are adjusted, shapes are refined, and edges are made distinct or lost until the desired unity is achieved. As soon as this occurs, it is time to stop.*

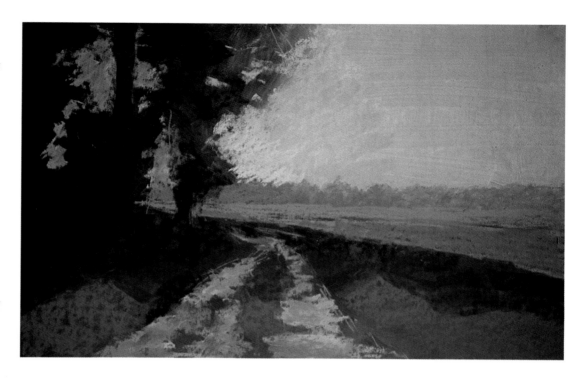

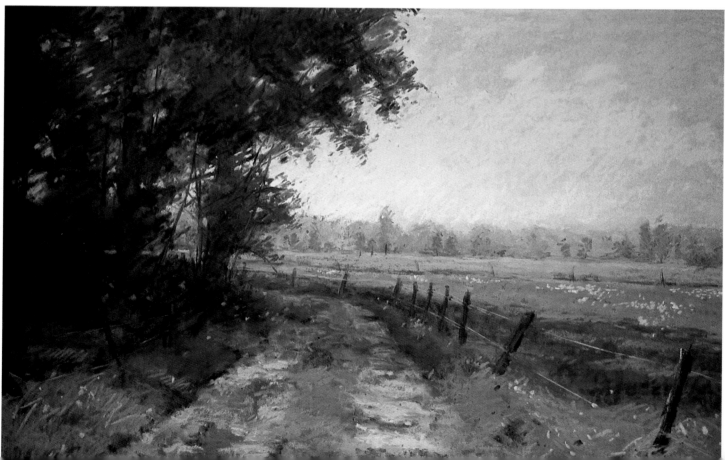

Expressing the Warmth of Summer

The words *summer* and *warm* are synonymous. When you highlight grasses, flowers, and rocks, reach for sun-dried colors that remind you of heat and dryness. Open up to input from all your senses! Allow your feelings and experiences to convey personal expression. For example, when I paint strawberries, I always recollect images of picking them as a child—the squashed berries, the stained pockets—and the joy of discovering the first glimpse of red peeking out from beneath the familiar trio of leaves at the beginning of each summer. When we are moved by even the simplest of life experiences, chances are greater that we will move others with our work.

PEMBROKE BAY, AFTERNOON
Pastel on Sennelier La Carte, 11 × 25" (28 × 64 cm).

Here, a warm-colored sky creates the mood of late summer when mature grasses take on some of the same hues.

SOME AREAS OF A PAINTING CAN BE
MADE LESS IMPORTANT BY USING
SIMILAR VALUES OF DIFFERENT COLORS.

NOTICE THE JUXTAPOSITION
OF COOL AND WARM GREENS.

PURPLES HAVE BEEN
INTRODUCED INTO THE
DARK-VALUE GREEN.

THE STORY OF THIS PAINTING EXISTS
HERE AT THE EDGE OF A MOWED
FIELD, WHERE ONE WOULD ENTER
THE UNCUT MEADOW.

YELLOWS HAVE BEEN
INTRODUCED INTO THE
LIGHT-VALUE GREENS.

SHADOWED WOODLANDS AND
FLOWERS ON THE RIGHT DO
NOT COMPETE WITH SUNLIT
AREAS OF THE PAINTING.

DAISY MEDLEY

Pastel on Ersta sanded paper,
14 × 32" (36 × 81 cm). Private collection.

ABOVE: *A green landscape can become poetic with the creative introduction of other colors within the greens.*

OREGON RIDGE

Pastel on Wallis paper, 9 × 10" (23 × 25 cm).

RIGHT: *In western parts of the United States, grasses turn golden earlier than in the east. This is also true in warm and dry climates all over the world. Here, the warm color tells us that the season is unmistakably summer.*

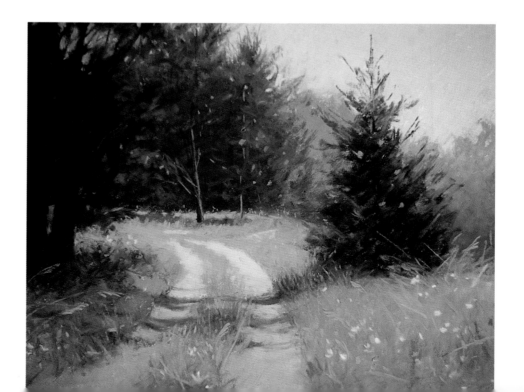

PAINTING WATER IN PASTEL

During the long, warm, summer days when much of our time is spent outdoors, many of the places we like to be are near water. So it follows that many such scenes will find their way into our pastel paintings.

Heightened perception is the key to painting water in pastel. We must train ourselves to observe whether the water is near or distant, moving or still. The effect of light on water and the influence of weather and atmosphere should be considered. Also notice where and how water gets its color; why reflections are sometimes mirrorlike and, moments later, become broken lines of color; and how to simplify your pastel strokes to capture the essence of water's movement without tediously attempting to paint the entire reality. Using a camera to strengthen your observations can be helpful, but avoid substituting photos for first-hand studies made directly at the scene.

As you develop your skills at painting water, use your pastels as either a sketching or a painting medium, depending on your preference and intent. When you are sketching water, use a good-quality pastel paper. Since much of the paper is left exposed in a sketch, you will most likely go immediately to the focal points of your subject matter. With backgrounds that are minimal, pastel strokes can be kept away from the paper's edges, and focus will remain intact. You may decide to sketch as a personal resource for future paintings, but whether you do or not, a lot of information can be put down quickly in a sketch.

When you cover your paper surface completely with pastel, it becomes a painting, as opposed to a sketch. Even though pastel is very direct, you will become involved in building up layers of pastel on the textured or abrasive surface. When painting with pastel, plan ahead by determining the scope of your work and the effects you want.

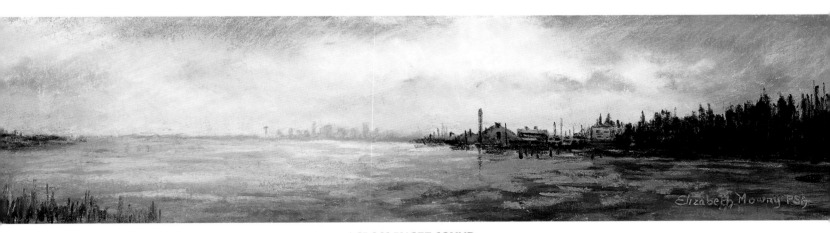

ACROSS PUGET SOUND
Pastel on sanded board, 3 1/2 × 15" (9 × 38 cm). Private collection.

Here, several layers of pastel cover the entire surface of a sanded board, which has been cut to size with this painting in mind. Although the painting process was spontaneous, the idea for it was well-conceived.

Shallow Water

In summer, streams become shallow, leaving islands of flat rock and interesting little water pools. Dry conditions provide an opportunity to reach the previously inaccessible far banks of streams, whose swollen waters raged assertively over the same areas in spring. Now we can cross streams as we decide on the views we wish to sketch and paint.

Foreground water is sometimes relatively shallow and more transparent as you look down into it, revealing warm colors and the shapes of stones and pebbles on the bottom. In such cases, paint the streambed first, then pull a blue or green pastel pencil of similar value over it to indicate the presence of water over the stones. If you prefer using soft pastels for this step, you might work with a tortillon to remove some stroke textures in order to maintain a sense of transparency.

As water recedes into the distance, the angle at which you view it changes, and more reflected light from the sky will be seen on its surface. In the far distance, reflected light strokes in your painting will eventually close up and blend.

When you consider the color of water in your painting, remember that it reflects the sky. In most cases, your painting will have more unity when you paint water a slightly deeper tone than that of the sky color. Another tip: Using directional strokes with a sky-related pastel color gives movement to foreground water in a paintings.

When you paint shallow foreground water, put in the earth and rock colors first. Then lightly pull a blue pastel pencil over the rocks and pebbles to blur some of the shapes directly below you. As water recedes into the distance, it will pick up more light from the sky on its surface.

MARSHLANDS, MAINE

Pastel on sanded paper,
8 × 18" (20 × 46 cm).
Collection of Renno and
Nora Budziak.

Look at how water takes on reflected light from the sky. As the water gets closer to the foreground, some directional strokes give it movement.

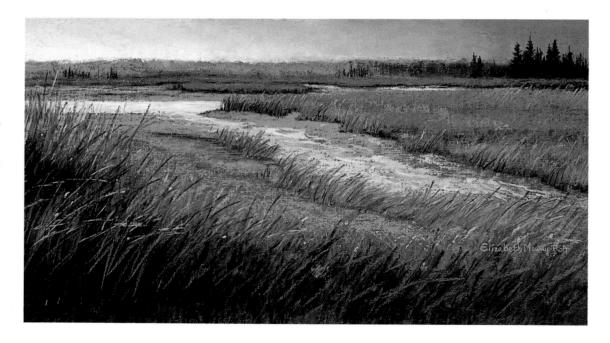

Deeper Water

Isolated ponds and lakes are a favorite summer subject for painting. Except for insect ripples on their surface, such bodies of water are usually silent and still. To portray these settings, rather than laying in color with a single tone to describe water in the near foreground, use a few different colors of the same or nearby value. Diminish the size of your stroke with distance. When you apply several colors next to one another in broken strokes that visually blend together, the water you paint will be much more interesting. Using this technique in water foregrounds invites the viewer in for a closer look. A word of caution, though, about over-doing it: Whenever technique becomes more important than subject, your water will look contrived. For example, horizontal lines of a different value may be used to indicate the calm of a pond's surface. But overdone, this technique has the reverse effect, because too many horizontal lines are distracting, and they destroy a sense of quiet in the water.

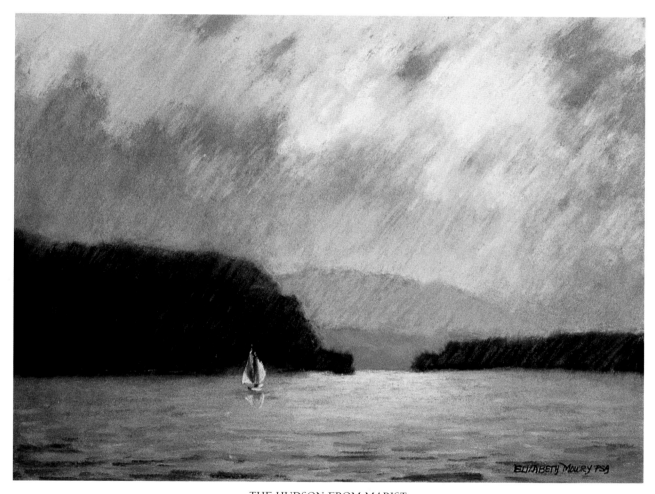

THE HUDSON FROM MARIST
Pastel on Sennelier La Carte, 9 × 12" (23 × 31 cm).

Subtle color conveys a melancholy mood in this painting. But note how value and color changes in my pastel strokes lend a sense of movement to the foreground water.

Reflections

Reflections tell us about the surface quality of water. Perfectly still water has a mirrorlike quality; rippling shows reflections broken into wavy patterns; moving-water reflections often bear no resemblance to objects being reflected, but capture the viewer's attention with their intricately colored designs. When your intent is to use those designs in your paintings, you may need the aid of a photo to freeze such patterns for you.

Decide ahead what you want to emphasize in each of your paintings of water. At times, you may even want your painting to show water that reflects part of a landscape that is outside the scope of your composition. In that case, use reflections to tell the story about what is surrounding the water. But beware of getting caught up in painting reflections to the point that they overpower your picture. Instead, keep reflections harmonious with the image as a whole. Do this by painting reflections with slightly softer edges and less bright colors than the reality. And always work toward unity in your paintings. Dynamic parts of a painting do not always add up to a unified wholeness.

Dark Water

Water frequently appears to be black in summer, in which case it is best portrayed using a dark-value green or indigo. Sometimes you will see lighter, warm, yellow-green vegetation stretch fingerlike across the dark water, punctuated only by varieties of the wild water lily. Keep vegetation shapes in your painting flat in the background and middle ground, painting water lily pads, for example, rounder only as they come nearer. If you look closely, you will see traces of sienna, orange, and bright blue-green within the floating green masses. Take advantage of the opportunity to play up striking contrasts between dark water and warm, light-colored vegetation by overstating the colors a bit.

WATER LILIES, PART I
(Top right) Pastel on sanded board, 12 × 36" (31 × 92 cm). Private collection.

WATER LILIES, PART II
(Bottom right) Pastel on sanded board, 12 × 36" (31 × 92 cm). Collection of Andrew and Ingrid Novak.

In this pair of water lily paintings, I used purple, green, and blue soft pastels to paint the water. Keeping each color close in value to the one next to it eliminates the need to blend. Using soft pastels gives water depth and liquidity because they fill the paper's tooth, then visually blend together.

DEMONSTRATION: *Painting Reflections on Water*

In this demonstration, I wanted to portray the impression of the gentle Seine as it flows through the French countryside. I used a horizontal format that allowed the river to "flow" across my painting as well.

With patience, your perception of water will develop gradually. Once you learn to sort through what you see and use only what is most important, it can become quite easy.

STEP 1: FIRST LAYER OF COLOR. *Your first color layer can be applied quickly with broad side-strokes, using only soft pastels. The key to flexibility is to apply the pastel lightly. In this step, composition is blocked in with approximate color values in the large shapes.*

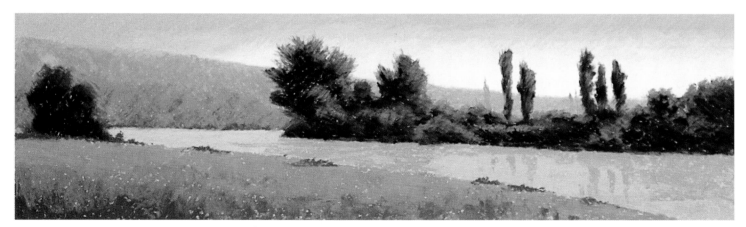

STEP 2: SETTING THE MOOD. *More pastel goes into the sky area, pulling one color into another and closing the stroke. I shaped the trees with lights and darks, using blue at the edges where they meet the sky. Next, I liquefied the water with horizontal strokes of several soft blue pastels, then warmed the foreground with ochre and warm green, and inserted sky holes in the trees sparingly.*

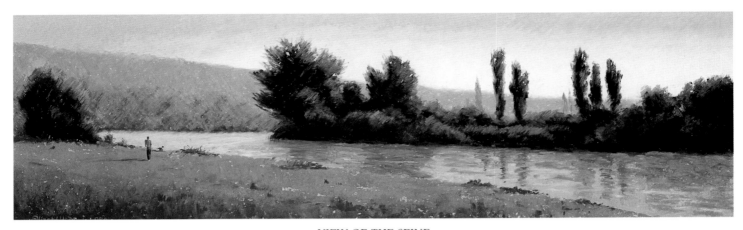

VIEW OF THE SEINE

Pastel on sanded board, 13 × 31" (33 × 79 cm). Collection of Frank E. Davis, Jr.

STEP 3: FINAL DETAILS AND ADJUSTMENTS. *To finish, I intensified the water reflections with purples. To set scale, I drew in the figure and dog with pastel pencils, then detailed the grasses and brush at the edge of the water. After a more critical look several weeks later, I made small adjustments, softening some edges and unifying color.*

CANAL, PROVENCE

Pastel on Wallis paper,
9 × 12" (23 × 31 cm).
Collection of Andrew and
Ingrid Novak.

Here, vertical tree trunks reflected in a gentle stream are grounded by diagonal shadows, a small but important part of the composition.

A SPOT OF LIGHT
PROMISES A
CLEARING SKY.

IN AN ALL-GREEN PAINTING YOU
CAN DEFINE SHAPES BY THE USE
OF WARM AND COOL COLOR.

GREEN INTENSIFIES IN APPEARANCE
AFTER A RAIN STORM. IT CONVEYS THE
SAME SENSE OF WETNESS AS THE WATER
COLLECTED IN THE MUDDY ROAD.

THE CENTERED ROAD TAKES THE VIEWER
DIRECTLY TO THE FOCAL POINT, ALSO
CENTERED. PLACEMENT AND SIZE OF THE
TREES MAKE THE COMPOSITION WORK.

A GREEN SUMMER PALETTE
WORKS WELL WHEN VARIATIONS
IN COLOR TEMPERATURE AND
CHROMA COMPENSATE FOR THE
LIMITATIONS OF HUE.

MUDDY ROAD

Pastel on Wallis paper, 11 × 15" (28 × 38 cm).

*The wet landscape that we frequently see after a summer shower is evident here in the refreshed
green of the grasses and the water collected on a farm road. As an alternate to sun and shadow,
be mindful of seasonal conditions that convey your close communion with nature as your subject.*

Choppy Water

When water is active, moving, or choppy in the foreground, study it for activity patterns. Although waves differ from one another, look for repetition in their movements. You will need at least three values of color. Notice that the flattest parts of rolling water reflect the color of the sky. Deeper color shows up under the wave's crest. Relying on photography will stop the movement for a split second and show you what to look for.

Most important of all, try to simplify when portraying choppy water. Paint some close-up waves with detail, then use less and less detail as the water recedes into the distance. Too much repetition will get boring for you and for the viewer. By implementing suggestion through expressive strokes, you can use personal interpretation to share what you perceive, according to what you feel about the subject.

Dependence on pat formulas or rules is not always helpful, because bodies of water do not always share like characteristics. For example, ocean waves are different from river waves or from those in stormy seas. Learn as much as you can about your subject, and with the information you gather, trust yourself to formulate guidelines of your own.

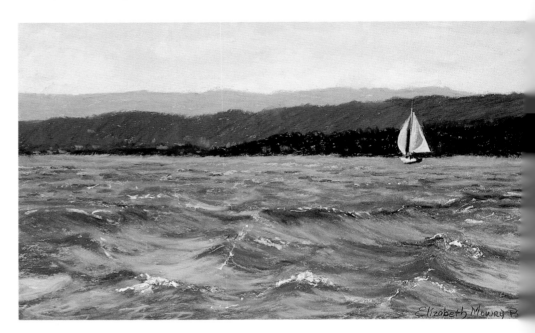

SAILING ON THE HUDSON
Pastel on sanded paper, 6¹/₂ × 11" (17 × 28 cm).
Collection of Albert and Gudrun Novak.

Sweeping, closed strokes curving upward give a choppy roll to the purple, indigo, and warm gray water in this foreground. I created a hint of foam at the top of the waves by rolling the tip of a light-tinted pastel on the surface. Short, horizontal strokes take the water to the far shore. Personal meaning gives focus to my work again and again. In this case, taking sailing lessons is what prompted me to create this painting.

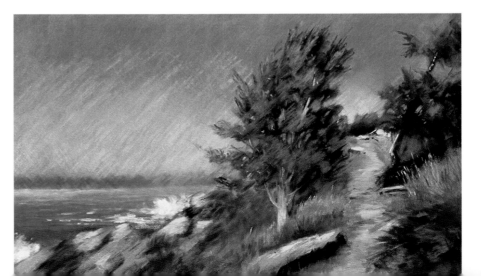

WINSLOW HOMER'S PATH
Pastel on Sennelier La Carte, 12 × 19" (31 × 49 cm).

Here, the suggestion of water crashing against shoreline rocks is achieved by applying gentle strokes of white soft pastel. These few strokes constitute the highest value in the painting.

Distant Water

Distant rivers are the easiest of all water to paint. They appear in the landscape as thin ribbons of color, usually a tone darker than the sky. Probably the only way a distant river can be responsible for a failed landscape painting is if its configuration is inaccurate.

Many times, water in a landscape painting is too far away for any detailed stroke to be needed. Instead, it will appear to be an even tone of one or several values, deepening in color where it is closest to you. You may see a few long, horizontal streaks where light catches a surface pattern caused by a shift in current or depth.

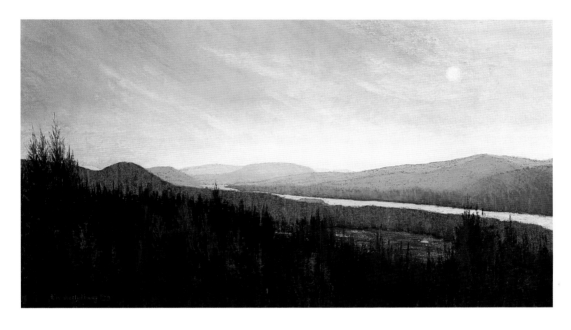

TOWARDS PEEKSKILL
FROM THE HIGHLANDS
Pastel on sanded board,
20 × 36" (51 × 92 cm).
Collection of Michael Skelly.

In this example of a distant river painted in pastel, a thin slice of water divides the landscape horizontally. Pay close attention to the shape of water, and paint it a color that is similar to the sky or slightly darker.

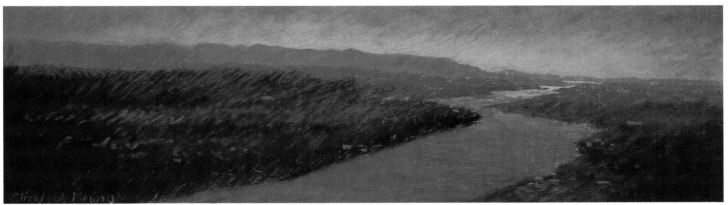

HUDSON RIVER AERIAL VIEW #4
Pastel on Ersta sanded paper, 6 × 20" (15 × 51 cm).

Here, the linear path of water begins in the foreground and guides the viewer's eye toward the horizon. Very little definition is needed in water that is far away.

85

PAINTING FLOWERS WHERE THEY GROW

Flowers complete the summer landscape. Dwarfed by lofty skies and leafed-out trees, they claim their unassuming places along roadsides, in shady glens, and in spacious fields. Growing flowers, as opposed to cut flowers in a vase, thrive in their unpampered freedom. In nature, flowers are always in harmony with their setting, balancing and complementing summer's greens and blues. In gardens, that is not always so.

When you want flowers to dominate your painting, give them the space they need. Use a large enough surface for leaves to linger and untidy stems to sprawl into an asymmetrical composition. Above all, paint foreground flowers large enough to assume their rightful place at the center of interest. When deciding whether to include more or less in your painting, choose less, and emphasize it more. Use a combination of detail and suggestion, lights and darks, soft and hard edges, small and large shapes, warm and cool colors.

When you exaggerate the size of flowers to many times their actual size and fill your painting surface with just a few of them, your work may become a decorative-design piece. If that's the direction you choose, be aware of the elements that constitute good design of that genre.

Personally, my favorite way to paint flowers is to make them an integrated part of the landscape. In their natural habitat, flowers can lead the eye through a landscape with their color. In addition to studying the details of a single flower, notice how flowers group themselves in natural settings. Each variety has its definitive grouping characteristics. Before long, you will know just which flowers in your area grow in the shade, which thrive in sunlight, and which prefer marshy wetlands.

HAY BALES

Pastel on Ersta sanded paper, 4 × 10" (10 × 25 cm). Collection of Sidney and Anne Craven.

Sun-drenched fields of summer are a familiar landscape in many parts of the world. The sunlight and shadows on the hay bales are a small but important part of this painting.

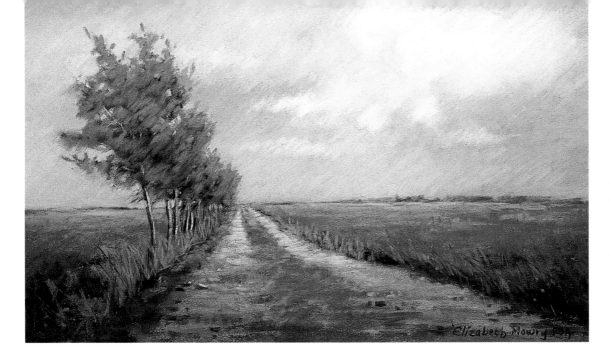

HIGH ROAD
Pastel on Sennelier La Carte,
8 × 12" (20 × 31 cm).

This little study speaks of summer in the open countryside. I frequently try to capture the essence of a season in small studies with the intention of using what I learn in more extensive works.

VACATION PATH
Pastel on Wallis paper,
9 × 13" (23 × 33 cm).

In this summer landscape, compared with High Road (above), the foliage closes in an intimate space. Sunlight warms the mature grasses that line a sandy path in Maine. The feeling of restful quiet is conveyed by the lack of any activity.

Foregrounds and Backgrounds

At the same time that you haze over the backgrounds in your summer landscapes, you can stroke in sun-ripened, lively foregrounds with expressive grasses and a few selected details that lead into the painting.

Far off in the distance, flowers are painted as massed specks, or, in larger numbers, as a layer of color bluer or grayer than the foreground flowers. To capture the essence of a flower, study its petal shape carefully. See how lupine (spike), poppy (cup), and daisy (narrow, circular) differ.

It is the simplified shape of flowers that suggest their presence as they move from foreground to background, losing details along the way.

Remember when painting flowers in their natural setting that they grow wherever seeds fall; they are not lined up and evenly spaced as in a garden. See how some hide behind others, making them only partially visible. Notice how groups of flowers crowd together within wild grasses. Look for the shadows they throw across one another. This discontinuity and abandon give flowers their elusive charm.

The characteristic spikes of the lavender are evident in the foreground only.

Definition gets lost as the wild lavender flowers recede.

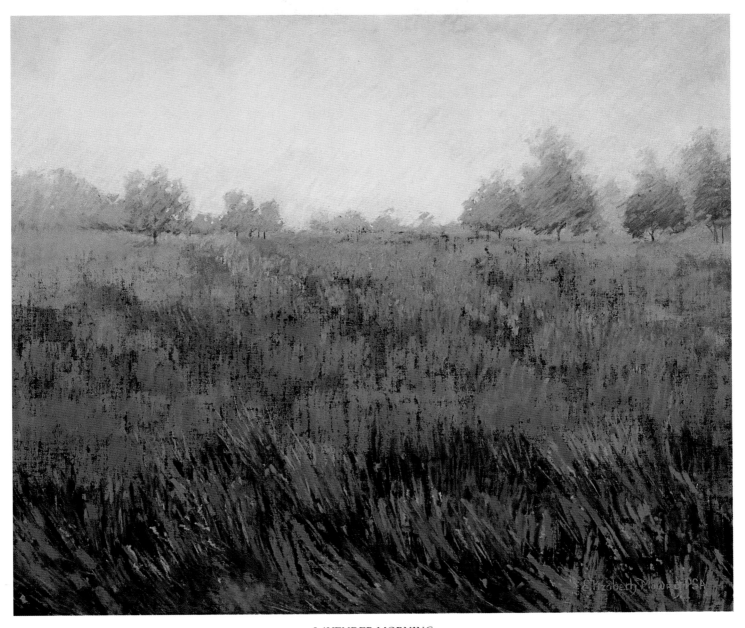

LAVENDER MORNING

Pastel on Ersta sanded paper, 18 × 20" (46 × 51 cm).

This ultra-simple painting pays homage to my favorite flower. Notice how detail disappears in the background.

SUNLIGHT ON THE LANDSCAPE

Sun dominates the summer landscape. Whether it lights up the entire side of a tin-barn roof or just a few petals of a flower, the effects of sunlight as it dries and warms the earth are obviously important to any artist. Keeping a close watch on how landscape changes with the presence (or absence) of sunlight is the key to solid summer compositions.

When the sun is overhead, trees, now fully foliated, magnify their presence by laying cool shadows over the ground nearby. As the afternoon hours pass, imposing shadows claim more and more of the landscape. Capitalize on those shapes as a way to enhance your compositions.

The same sunlight that sometimes bleaches out the landscape at noon, much like an overexposed photograph, will throw enticing shafts of light into woodlands and across meadows earlier or later in the day. These patterns create the contrasts needed for transforming an ordinary scene into a well-balanced landscape. At dawn or at dusk, they become dramatic.

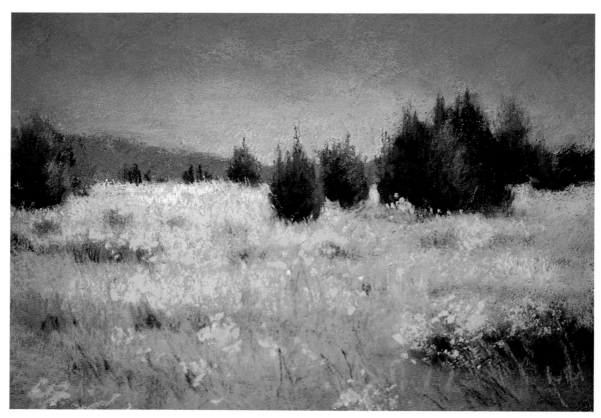

CORRALES COLOR
Pastel on mounted Ersta sanded paper, 5 × 7" (113 × 18 cm).

This small study is a tribute to the vibrant color of summer in the western part of the United States. It was painted from a photograph I took while on a drive with dear friends. The afternoon light provides only minimal shadows.

SUMMER-STILLED LIFE

Still life does not have to be synonymous with indoor studio painting. Except when it thunderstorms, summer is a season of quiet passiveness. Evidence of full growth, such as fruits still on the vine, invite us to take a closer look. Flowers in the field and garden that attract butterflies and hummingbirds keep changing from bud to seed. So much of what summer offers as subject matter is most appealing where it is.

Consider zeroing in for an intimate view of something that interests you, and paint it outdoors. Yes, the lighting will change, so you will need to block in light patterns first, then adhere to them as recorded.

Paramount to outdoor still-life painting and sketching is a thoughtful decision about the size of your pastel surface and the objects to be painted. Choose an ample surface so that your strokes will not be confined and tight. Then be sure to paint your subject large enough on the surface. Most times, this means cutting back on the scope of what you include so that your image can be large enough to make a strong impact. For example, I have a large raspberry patch that gives me much pleasure because I enjoy making gifts of jam, cordial, and tea with the berries. My associations with the patch are very positive, so it is a natural choice for subject matter. Yet, were I to paint the whole raspberry patch, the berries would be too small to be visible. By zeroing in on just a few of the leaves and berries, I pay homage to a place that holds personal meaning.

COOL REDS, GREENS, AND BLUES SUPPORT THE FOCAL AREA, WHICH IS WARMER.

BLUE IS USED IN THIS CORNER TO SUGGEST SKY.

I COVERED ALL BUT THE UPPER-RIGHT CORNER OF MY SANDED PAPER WITH DILUTED, TURPENTINE-BASED WOOD STAIN.

SUGGESTION IS SOMETIMES ENOUGH.

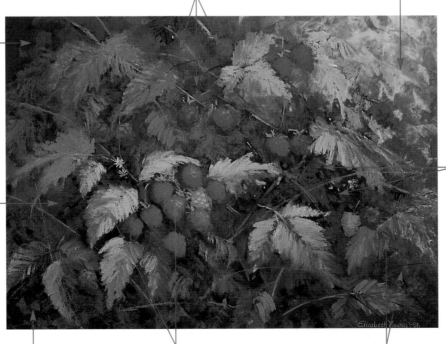

DARK GREENS AND PURPLES REPRESENT THE DENSITY OF SHADOWS WITHIN THE RASPBERRY BUSHES.

THE DARK SURFACE IS RESPONSIBLE FOR THE STRONG CONTRASTS THAT EXIST IN SOME PLACES WITHIN THE PAINTING.

WARM REDS AND GREENS ARE AT THE CENTER OF INTEREST.

SOME AREAS LOSE DETAIL AND CONTRAST AND BECOME UNIMPORTANT.

WINTERSET RASPBERRIES II
Pastel on Ersta sanded paper, 14 × 18" (36 × 46 cm). Collection of the artist.

For this painting, I used reality as a guide only. Once I painted the first leaves and berries, I added others only where I needed them on my surface to create a pleasing design.

91

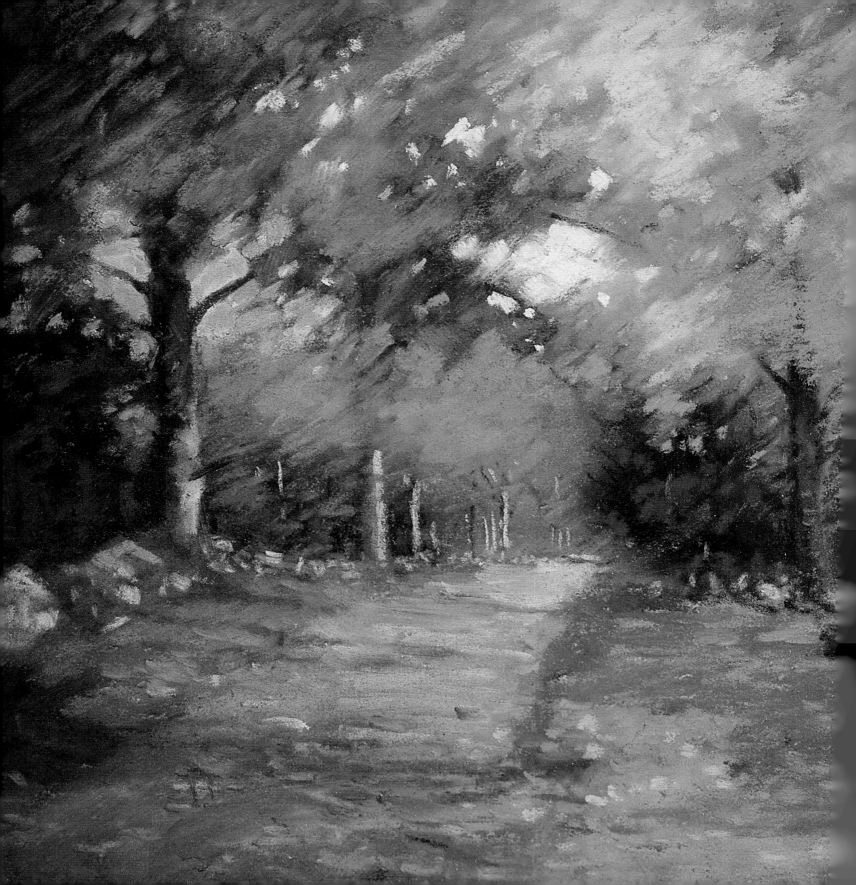

4
Autumn

PALEN ROAD (detail)
Pastel on Sennelier La Carte, 5 × 8" (13 × 20 cm).

Just a few warm autumn colors light up this ordinary scene. The painting would have become unfocused and overloaded with color if bright red, orange, or green had also been introduced into the foliage.

93

A RESPONSE TO AUTUMN

The decline begins, but not before a final flourish. The transition from summer green to vibrant autumn color begins slowly. Verdant fields take on a bronze glow that gradually changes to ochre and yellow. Later, while the goldenrod fades, you can watch roadside sumac turn scarlet, and delicately draped crimson shows how high the poison ivy has climbed into the trees. Notice how the low sun backlights some trees and throws their long shadows forward across drying fields. Hear the crows call out to one another, as geese, in painterly formation, migrate south.

By mid-autumn, the spread of warm color over the landscape escalates to such a degree that even the untrained eye sees changes every day. Momentum continues until,

in the woods one cloudy day, you may mistake the brilliance of yellow foliage for sunlight. Out in the open fields, take note of how tall cornstalks have been cut into rows of stubble that converge at the horizon. Look for the orange pumpkins that dot tawny fields randomly. You may even see silken milkweed seeds catch a highlight in the sun as they burst from their pointed pods and float away. And all the while, the pungent smell of fallen fruit will be mingling with the scent of burning rubble from summer's finished garden.

As the season progresses, yellow becomes golden, vermilion replaces summer pinks, and orange ripens into burnt sienna. All of nature's color matures before our eyes.

PEARS, THREE
Pastel on solid ground,
8 × 10" (20 × 25 cm).

I took these three pears down from their tree and into my studio—moving a little bit of the landscape indoors, when temperature changes were not conducive to painting outside.

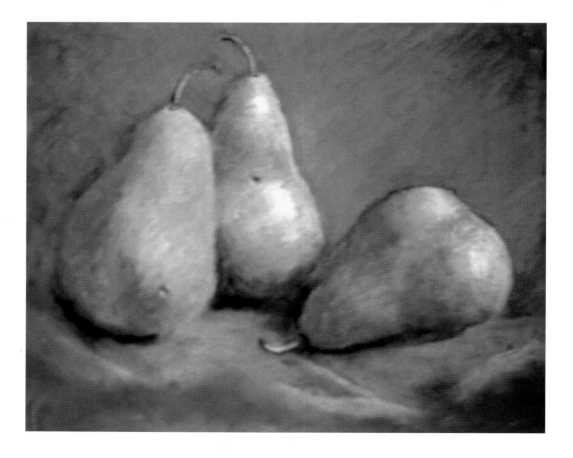

HINTS FOR BETTER AUTUMN PAINTINGS

Despite the advantage you have of being able to render autumn color swiftly with pastel, take time to absorb the vivid impact of the season before making hurried translations into paintings. This advice may seem counterproductive as the clock keeps ticking through the short color season and impending frost awaits. Let me explain further.

I have watched beginning painters, under the alluring spell of autumn color, hurry from one place to another in quest of the brightest subject matter, and understandably so. After the green, green summer, there is a tendency just to aim yourself at color and paint. But by hastily pursuing only color, you may be compromising composition.

Some years ago, as autumn approached, I decided I would capture all of its nuances that I had missed in other years. In the excitement of the season, I traveled around doing painting after painting. When my initial rush of activity was over, I finished the season by casually painting places I see every day right near my home. As you might guess, the early work was filled with glorious color, but only my final paintings withstood the test of time and my own critical eye. It was obvious that my later work, painted within the relaxed familiarity of my own neighborhood, showed compositional strength and grace that the earlier work sadly lacked. If this has not already happened to you, I hope that my misguided approach will serve as an example to spare you from a similar experience.

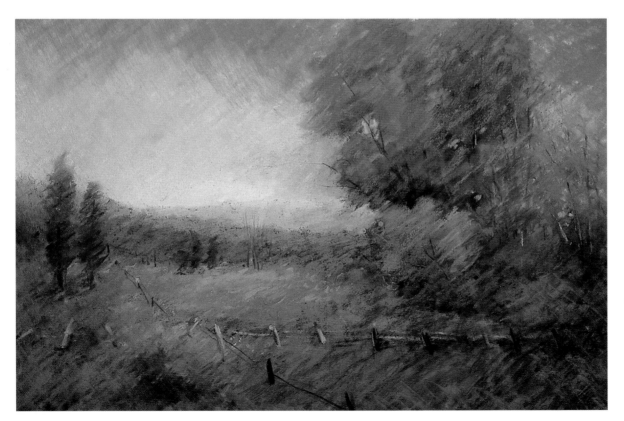

VIRGINIA AUTUMN
Pastel on Sennelier
La Carte, 9 × 13"
(23 × 33 cm).

Note how warm colors in the foliage are balanced by cool purples in the distance. Hard edges were not applied in this work, and the soft appearance of the scene is also due to the painting surface that I chose for it. Experience will teach you which surfaces suit your work best.

THE AUTUMN PALETTE

The colors we associate with autumn are warm, such as red, yellow, orange, ochre, and sienna. In fact, the palette of autumn, even with the less colorful November averaged in, is significantly hotter than any other season.

Because high color commands attention, we notice enticing warm and bright colors first. But since nature demonstrates exceptional balance at all times, take a good look again. See the violets, purples, rich blues, warm browns, and cool grays as you view the landscape, and keep this natural balance in mind as you put color into your paintings. For example, notice that when you place a scarlet maple near a cool green pine, it will appear extraordinarily vibrant. Many other lively complementary pairings are equally appealing.

Of course, your personal autumn palette will depend upon your own location and painting style. For example,

if you are a realistic landscape painter in Wyoming, your palette would probably include fewer oranges and reds characteristic of northeastern maples, and more yellow and ochres of the aspens. Your sky colors would also reflect the intense blues and purples that dominate large, open spaces in your region.

Some autumn paintings are not as effective as they could be because colorful foliage, so breathtakingly beautiful in the vast outdoors, can be problematic within the confines of a pastel painting surface when it competes for attention with the work's focal point. When that happens, try composing your painting with its brightest colors at the center of interest, and keep other colors in reserve. In other words, make the color be the focal point. Also, abbreviate detail. Detail draws attention and scatters focus as well.

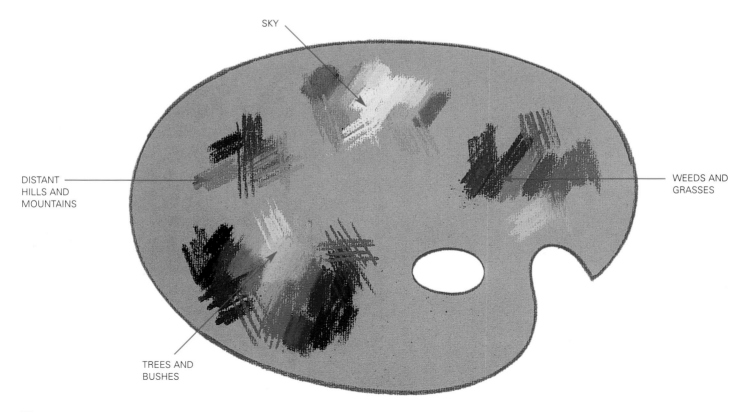

SKY

DISTANT
HILLS AND
MOUNTAINS

WEEDS AND
GRASSES

TREES AND
BUSHES

PAINTING THE AUTUMN SKY

Drama in an autumn sky is always changing. On a brisk, clear day, you might see a complementary cobalt sky above brightly colored foliage. The very next afternoon, the sky may be just a backdrop of gray for the passing parade of color beneath it.

Clouds often travel swiftly now. As temperature swings and air currents increase, diagonal clouds frequently slant across the sky in interesting patterns, while low, darker clouds hover above luminous horizons. In painting any of these clouds, your most important consideration are edges.

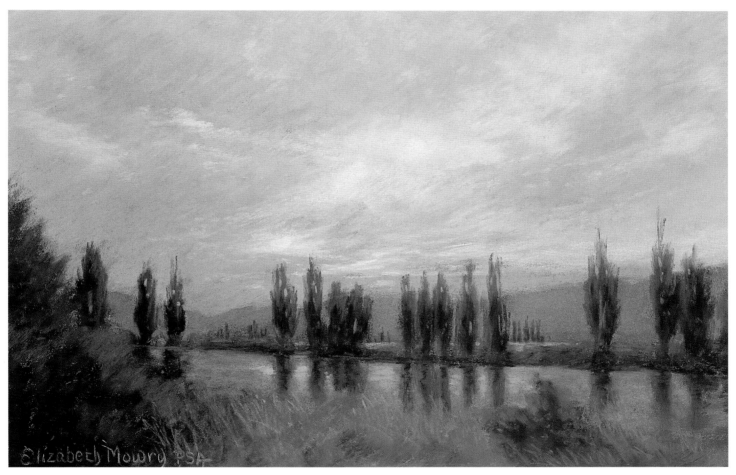

WILLAMETTE SKY

Pastel on Wallis paper, 9 × 14" (23 × 36 cm).

An autumn sky often dominates the landscape below it. The cloud formations in this Oregon sky show movement that draws the viewer's attention. If the landscape below the sky had been painted lighter or more vividly, it would compete with the sky, and the sense of quiet would no longer exist.

While soft edges are easily attained with pastel, be cautious about overblending. On the other hand, texture and hard edges, especially when overdone, can cause the end result to resemble a collage of glued-on shapes. Observe and then decide where a cloud edge should be emphasized and where others should be soft and therefore less obvious. Step back often as you paint, in order to avoid overworking in either direction.

Clouds, no matter how large or what shape, are still up in the vast sky, floating, free-moving, and airy. They are not separate from the sky, but part of it. They travel, change shape, appear to dissolve, and then take on form again. An impressive sky is not necessarily a heavily painted, overtextured one. Instead, clouds need a light touch. When painting a landscape, it is helpful to think of the contrast between the lifting, airy quality of the sky and the weighty solidity of the earth.

Make a point of observing cloud formations—their colors, shapes, and values. When a cloud is between you and the sun, its edges will appear luminous. If clouds are rounded, as opposed to stretched out, edges are usually their lightest part. Also notice how the darkest clouds of late autumn cause the earth beneath them to appear even darker.

For blending sky areas, try using a tortillon if you want softer results than achieved by pulling one color into another with your stroke. Sometimes I use a pastel pencil. I choose a color and value close to the tone of the area I wish to blend, holding the pencil almost parallel to the painting surface and using a very light touch. When there is enough pastel on the surface, the pencil will push color around rather than add more. That is why I often work on a flat surface instead of an easel, which allows tiny pastel particles to remain in the sky area and get pushed around as I work, creating soft edges where I want them. As my pencil smoothes out the soft pastel texture, the sky maintains a fresh appearance that would be lost if fingers were to touch the area. When working on a foreground, you may want lots of texture, whereas in the sky, temper that quality according to what is right for the painting.

And just what is right? I suggest saving final adjustments in the sky for your last step. Then, evaluate your entire painting back in your studio, where you can look at your work without comparing it to the actual scene. Then make adjustments as needed.

Capturing Sky Color and Movement

Do not be overwhelmed by a swiftly changing autumn sky. Study it briefly and set aside some of the colors you see in it, paying attention to the value range and temperature of the colors. Then compose and block in your painting. When you begin painting the sky, work swiftly and lightly as you distribute color among the large shapes, then zero in on one smaller area at a time for refining and blending. Reference photos are always useful for later work in the studio.

Familiarity with your pastels and knowing what you can do with them will enable you to paint skies that are exciting and fresh. Practice strokes, particularly edges, on little scraps of your best pastel paper or panel to see which effects you can obtain. This will eliminate frustration out in the field. At those times when clouds seem to race across the sky before you can get down what you need in your painting, turn to your file of sketches, photos, or small color studies for useful backups.

Sky Sets Moods

Whenever you fill a landscape sky with clouds and movement, your painting takes on an active mood. If other parts of your composition are filled with lots of color and detail, you will create a sense of tension. Handled well, moderate tension can be interesting and provocative, but in a landscape, overdone tension will be unsettling and cause your work to lose focus. Balance is essential.

The sky is often a key indicator of the mood that permeates a landscape. Paintings that succeed in portraying this link will be more successful than those that do not, even though they show skilled work. Graduated color,

either vertical or horizontal, lends a restful mood to a painted sky. Finding this quality and others through sky sketches will help build your awareness of how vastly different moods can be expressed in your landscape paintings.

After determining sky colors and values in your painting, consider the reflective qualities of those colors in lakes, rivers, and even puddles. Notice the way warm or cool light in the sky affects everything beneath it. Relate the temperature of highlighted parts in your painting to your chosen sky colors. In shadowed areas where objects fall in the path of the light, you can create the drama of a narrowed focus by refraining from highlights.

I taught myself techniques for sky treatment by doing little "sky patches," as I call them, like these—simple, horizontal-and-diagonal layerings of color in which one tone is pulled into another. For these studies, use the softest pastels you have. The direction of your stroke determines movement. Notice what cloud edges are doing. Even as the sky changes, you can add variations of the colors first applied, but keep your pattern of lights and darks intact. These sketches can be done quickly and spontaneously.

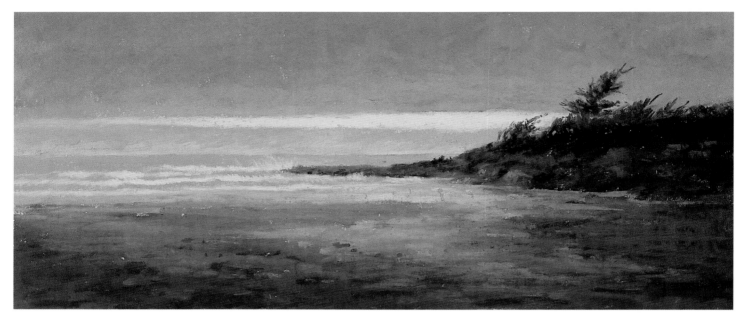

NORTH COAST

Pastel on Ersta sanded paper, 5 × 12" (13 × 31 cm).

Bending trees are evidence of the forces of weather after the fact. A single strip of light across the sky of this Pacific coastline captures the essence of the moment before the light disappeared. Simple on-site studies can be done even from your car, using only a dozen or so pastel pencils.

CANYON PATH

Pastel on Wallis
paper, 9 × 12"
(23 × 31 cm).

Here, a colorful New Mexican sky throws its light over the landscape. Each area of the world displays its own unique qualities as the seasons unfold.

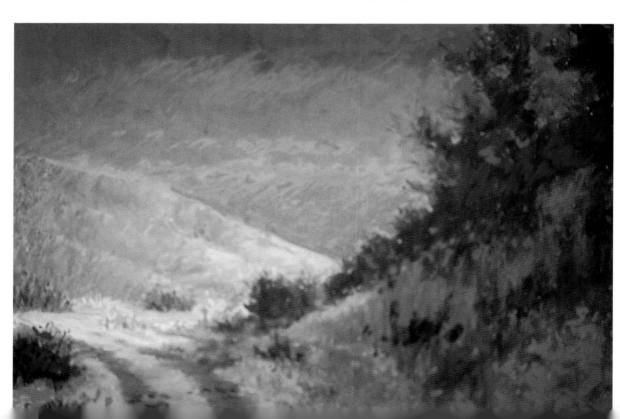

HILLS BEYOND THE
TREE LINE ARE
MORE GREEN THAN
THE MOUNTAINS.

FAR-AWAY MOUNTAINS
ARE GRAY BLUE
AND CONVEY
GREATER DISTANCE.

BOTTOM EDGE OF THE
TREE LINE IS BROKEN BY
EVERGREEN PLACEMENT IN
THE MIDDLE-GROUND FIELD.

NEAREST TREE GOES
OUT OF THE PICTURE;
IT ALSO INDICATES THE
HEIGHT OF OTHERS.

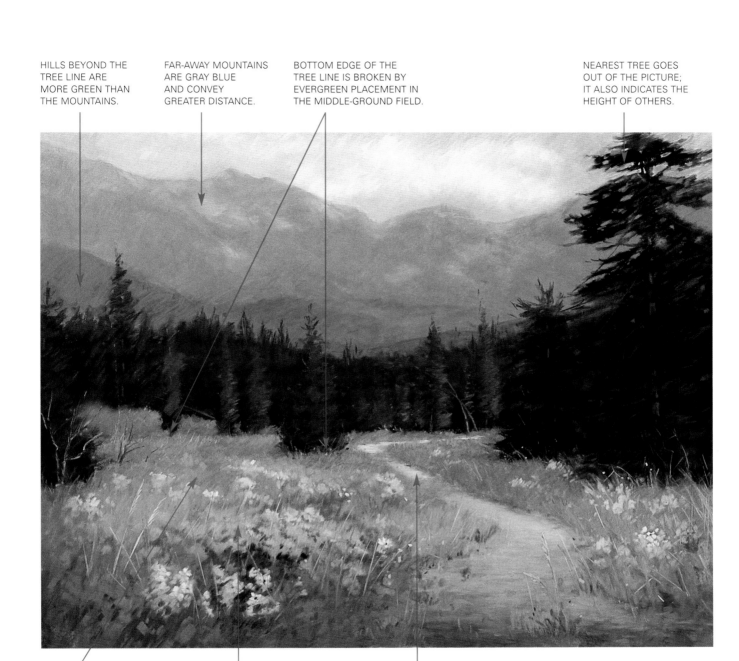

FLOWER MASSES
LOSE DETAIL AS
THEY RECEDE.

YELLOW-ORANGE FLOWERS
COMPLEMENT THE
PURPLE-BLUE MOUNTAIN.

LIGHT HITS ONLY PARTS OF THE
PATH, SO AS NOT TO COMPETE
WITH FOREGROUND FLOWERS.

THE BLUE AND THE GOLD

Pastel on Wallis paper, 20 × 24" (51 × 61 cm). Collection of John and Maureen Doss.

In this Rocky Mountain National Park scene, the blues and purples of the looming mountain and early-autumn yellow wildflowers were natural color complements.

101

UNIFYING AUTUMN COLORS

One of the most common ways to integrate color is by working on a colored surface, allowing the color of the paper or toned ground to become an integral part of the work by showing through slightly or even blatantly in many areas. Surface color harmonizes colors applied to it. Using surface color to unify a painting is an elementary pastel technique.

When you use a colored surface, the ultimate unity exists at the beginning of your work; then you control how much or how little of that color you want to keep as your painting develops.

Preselected Palette

Another way to keep color unified is by working with a limited, preselected palette. Since abundance of color is the hallmark of the pastel medium, you may feel restricted by the idea of color limits. But the concept suggested here can actually extend the range of what a few chosen colors will accomplish.

No matter which palette you select, with an adequate value range, you can create intriguing paintings with a color-limited palette. I recommend using a practice sheet for color exploration. Try strokes of color beside, over, and under one another to get an idea of what will work best for your subject matter. The more you work with the concept of preselected color, the more you will surprise yourself as to just how few colors are sometimes necessary for a pastel painting to be highly successful.

TOSCA'S
VALENTINE
Pastel on Ersta
sanded paper,
21 × 27" (54 × 69 cm).

I selected the palette for this painting with the idea of expressing strong color in a unified manner. The red tree is able to retain its importance due to the subdued treatment of everything else. Composition is based on a strong armature of vertical, horizontal, and diagonal lines.

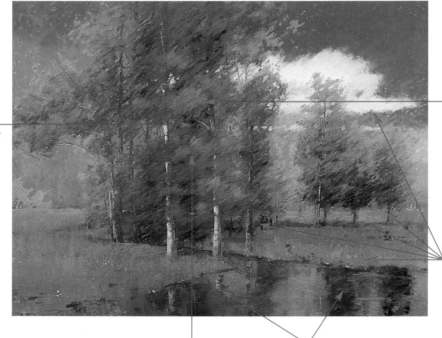

FOCAL POINT IS LOCATED NEAR THE PAINTING'S CENTER.

INTENSE RED IS SUPPORTED BY THE SUBTLETY AND LOW CHROMA OF ALL OTHER COLORS.

STRONG VERTICAL AND HORIZONTAL LINES ADD COMPOSITIONAL INTEREST.

A SINGLE RED TREE TELLS THE STORY OF AUTUMN.

REFLECTIONS REMAIN SECONDARY TO THE FOCAL POINT.

DEMONSTRATION: *Preselecting Your Palette to Vary Reality*

If you tend to rely on copying colors from nature or photographs more precisely than you wish to, preselecting your palette will help you to keep color mentally separate from form. It will also ensure the color unity you need to convey a mood.

In this demonstration, the composition features tree and shadow shapes shown in a picture that was taken very early in autumn. But I wanted to depict a mature, rather than a young, season, so I preselected a palette of primarily warm colors to ensure that my painting would convey autumn at its height. A harmonious, preselected palette also brings unity to an entire painting.

STEP 1: COMPOSITION. *When I happened upon these splendid shadows spilling out across meadow grasses behind my home, I was happy that I had my camera along. Later, I moved my viewfinder around on the photo until I had cropped all but that part of the image that interested me most.*

STEP 2: PRESELECTED PALETTE. *To convey a matured autumn mood in my painting, I chose a primarily warm palette of Naples yellow, ochres, raw sienna, low-chroma greens, red browns, and as a complement, two tints of blue purple for a minimal background. To create a warmer look than the photo, I tried each color with others until my value range was complete and I was pleased with the way all the colors combined.*

STEP 3: LARGE SHAPES.

My soft pastels were applied in loose, broad strokes to establish all large shapes in high- and low-value areas. Since the palette had already been selected, I was no longer encumbered by color decisions and possibilities that would dilute my focus and the mood of the painting.

OCTOBER
MORNING SUN
Pastel on sanded paper,
6 × 10" (15 × 25 cm).
Collection of
Frank E. Davis, Jr.

Choosing colors from my preselected palette to soften, darken, or lighten areas, I laid in the tree trunks and shadows and used a slightly harder pastel to integrate some of the colors. A meager thirteen pastels were used to paint a scene that would have lost impact with a full palette.

Palette Variations

Once you select your subject matter, decide whether you want to use colors based on those you actually see or creative variations. The choices at your disposal are many:

Monochrome: This palette contains a single color only, with a few or many value changes, according to preference.

Analogous: Related colors, such as violet, red violet, and blue violet are chosen. An analogous palette with a *complement* might be orange, red orange, and burnt sienna with a touch of blue.

Complementary: Any two opposite colors on the color wheel, and all variations that would result from combinations of the two.

Low-chroma: Colors that have been softened and made less intense by mixing them with complements or with other colors.

High-key: Primarily light colors at the upper end of the value scale.

Low-key: Primarily dark colors on the lower end of the value scale.

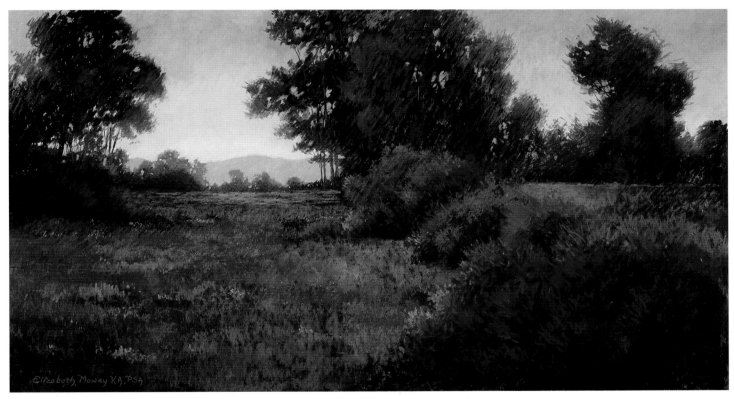

SEPTEMBER

Pastel on sanded board, 20 × 38" (51 × 96 cm). Collection of Albert and Gudrun Novak.

In this painting, I used several methods to unify color. First, I selected a palette to convey the harmonious mood I wanted to create. Then I brushed Turpenoid over the first layer of color in the lower portion of the painting for additional unity. Finally, some areas needed cross-toning to quiet the color. Unified color can transform the character of a pastel landscape from one with skillfully scattered color excitement to a statement of peace and composure.

Cross-Toning for Unity

Cross-toning a pastel is comparable to glazing an oil painting. In this procedure, all of the colors already in a painting are toned by open strokes of another color or several analogous colors to achieve a specific effect. Applied near the completion of a work, cross-toning can help the eye to blend and unify color.

To cross-tone an area, apply light, open strokes over existing colors in a direction different from the one already used. Vary the pressure according to how much additional color you want to leave behind. Most often, only a hint of cross-toning color is enough. Edges may soften, but existing shapes will not be changed.

Some effective colors in cross-toning for a warm effect are ochre, sienna, and sometimes magenta. Blue and purple work well for a cool or distancing result. Experiment with these and other colors on a practice surface to determine which ones produce the desired outcome.

Use cross-toning with discretion. It will not correct a poorly composed painting, nor will it mask incompetent drawing skills, and overdone, it will destroy the freshness of clean work. However, used wisely, cross-toning is an effective technique for putting distance into background hills and mountains; for harmonizing a foreground that calls too much attention to itself; to add interest to an otherwise flat area; and to warm or cool an entire painting.

While this painting may appear to be complete as is, the cross-toning that I added as a last step, shown below, throws an especially appealing aura over the scene.

ROSE GLOW

Pastel on sanded board,
12 × 16" (31 × 41 cm).
Collection of Paul J. Pacini.

Cross-toning, using two values of red-violet soft pastel, has changed this painting considerably. Using small color studies before applying cross-toning offers the opportunity to try more than one approach.

NEW PALTZ ROAD I
Pastel on Sennelier La Carte,
10 × 10" (25 × 25 cm).

This painting seems a bit out of place in a chapter devoted to autumn scenes. It is included to illustrate how different palettes—this one compared with the one shown in the painting below—can transform the look of the same vista.

NEW PALTZ ROAD II
Pastel on Solid Ground panel,
12 × 16" (31 × 41 cm).

This painting began in the same manner as the version above. Then, before completing it, I introduced a heavy cross-toning of the entire surface, using warm pink and rosy soft pastels.

LATE AUTUMN'S TRANSITIONAL PALETTE

The final phase of autumn arrives overnight with the first substantial frost. When colored foliage falls, sometimes within a few days, the change is dramatic. Between leafless trees, now we can see far into the woods. Mountains, hidden in summer, become visible again. Rock walls are more interesting now than at any other time of the year. Notice how the low November sun accentuates the soft and hard edges of the gray stone shapes that are entwined here and there by frost-ripened bittersweet.

Nature's limited palette of remaining color is often overlooked because of the excitement that has just passed, but there is restful harmony in what lingers. Subdued grays, browns, and blues are dominant now—delicately balanced by warm purples and ochres. Clouds with their luminous edges stretch across rosy sunsets. Open meadows still show the greatest variety, depending on what grew there earlier in summer. Purple fields, once majestic in their glory, are now a surprising, rich sienna. Berry patches and woody-stemmed brush take on a deep, magenta glow. Warm earth colors wash up against the cool grays of trees and sky.

I really enjoy painting the landscape in this last part of the season. I exchange the multitude of colors in my painting box for a meager pocketful of pastels and do quick color studies outdoors. Value becomes more important than color in my compositions now. Nature simplifies itself, and the uncomplicated landscape provides space for the feelings of the artist to become part of the work.

IDAHO BARN, AUTUMN
Pastel on handmade surface,
10 × 18" (25 × 46 cm). Collection
of Wendy R. Parish.

Within the quiet, low-chroma palette of late autumn, contrasts in value and color temperature can be used to create a pleasing composition. Here, cool blues and purples in the mountains and barn roof are balanced by warm ochre grasses and the cedars and tangle of foreground briar bushes painted with sienna and violet. This is an example of how color can convey mood; in this painting, the barren isolation of oncoming winter.

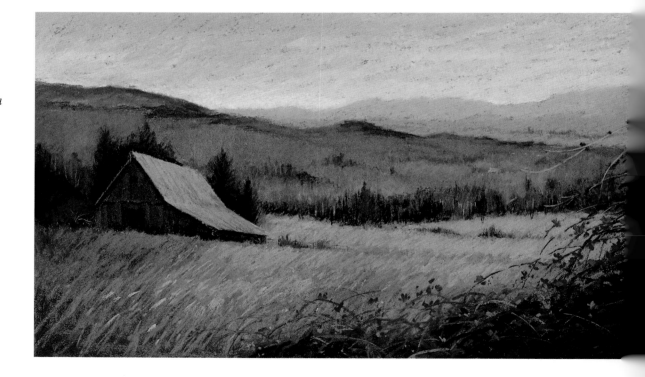

LEFT: *When time is limited or the weather cold and threatening in late autumn, begin your studies at the center of interest and work outward. Once your focal point is in place, if you must leave the painting site, you can complete your study in the studio. That is how this sketch began one cold morning–simply as a study of a building.* **RIGHT:** *Back in my studio, I worked outward from the center of interest, stroking in the setting for the barn just as it appeared, with dark grasses in the foreground and a gray sky overhead.*

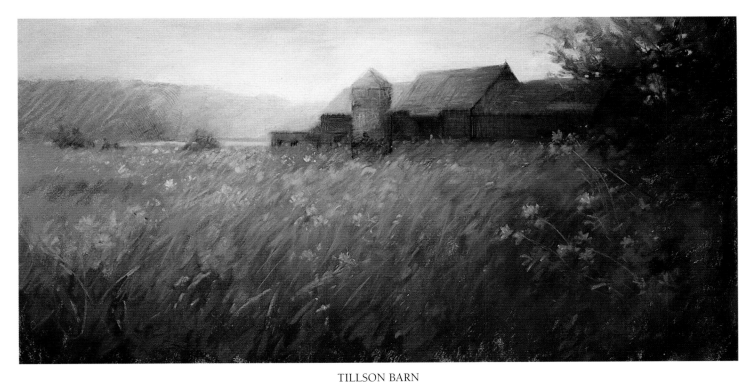

TILLSON BARN
Pastel on Sennelier La Carte, 9 × 20" (23 × 51 cm).

Weeks later in my studio, I became curious as to whether it would be possible to change the mood of the study without using direct sunlight. It didn't make the study better, just different. By considering a piece of work a study, you invite yourself to take risks and to continue learning.

DEMONSTRATION: *Colors of Late November*

A view of the Catskill Mountains near my home shows a simple, layered landscape that changes character as each season unfolds. In late November, when it is cold but sunny, the leaves that fell in October have all blown across the fields into their own hiding places. Mountains have usually had their first snow by now, but in the valley, brittle grasses still catch the afternoon light.

When you are painting a scene such as this, in which the palette is subtle and the composition appears deceptively simple, it is essential to construct a value range with effective contrast, or the painting will be lifeless. Here, creating sufficient contrast where grasses meet woodland was especially important.

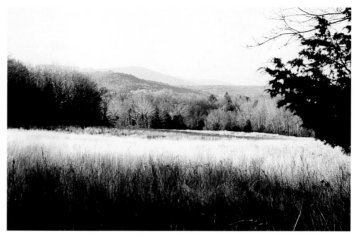

STEP 1: COMPOSITION. *This photograph of a favorite vista of mine, taken in late November, provided inspiration for one of my last paintings of that season.*

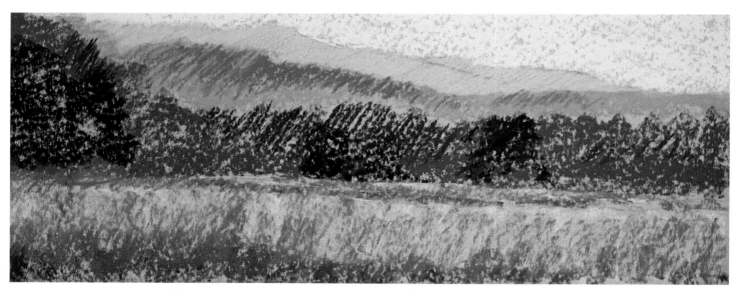

STEP 2: LARGE SHAPES. *On location, I apply the first pass of soft pastel. This establishes all basic shapes that compose the landscape—in this case, put down in layers of subtle color. Deep ochre in the foreground will show through light grasses later.*

110

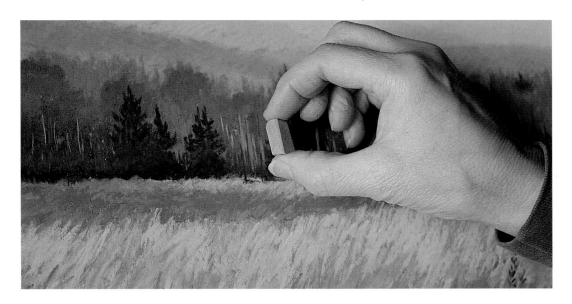

STEP 3: VERTICAL STROKES. *By using the edges of squared pastels in vertical strokes, I suggest the direction of dark and light tree trunks within the wooded area.*

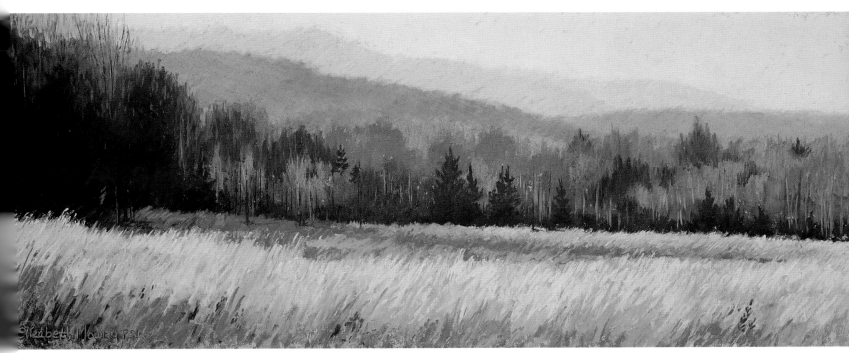

NOVEMBER AFTERNOON

Pastel on sanded board, 9 × 23" (23 × 58 cm). Collection of Judith and John Missell.

STEP 4: FINISHING TOUCHES. *Bits of warm sienna and blue are added to the tree line and foreground grasses. I cross-tone deep purple into the darkest mass at the left, then, with a wiggly stroke of light yellow ochre, I indicate the edge of the field against trees on the right. The painting surface is still fresh and clean because all the strokes have been lightly applied.*

111

ZEROING IN ON THE HARVEST

Autumn is traditionally a time of harvest, when man and beast prepare for winter by storing and preserving the fruits of summer's growth. There is a sense of urgency as daylight hours shorten and a chill permeates the air. As an artist whose subject matter is nature, you may recognize the tendency to hold on to what is passing by taking what remains of the fading autumn season indoors to paint.

As you become more and more in tune with nature's recurring cycles, you will be alert to signs that can expand the scope of your work immeasurably and lengthen your autumn painting season.

COLORED GROUND SHOWS THROUGH DARK CROSS-HATCHING.

HIGH-CONTRAST AREAS.

HIGH-CONTRAST AREAS.

WIDE RANGE OF VALUE DISTRIBUTION LENDS STRENGTH.

LOW

HIGH

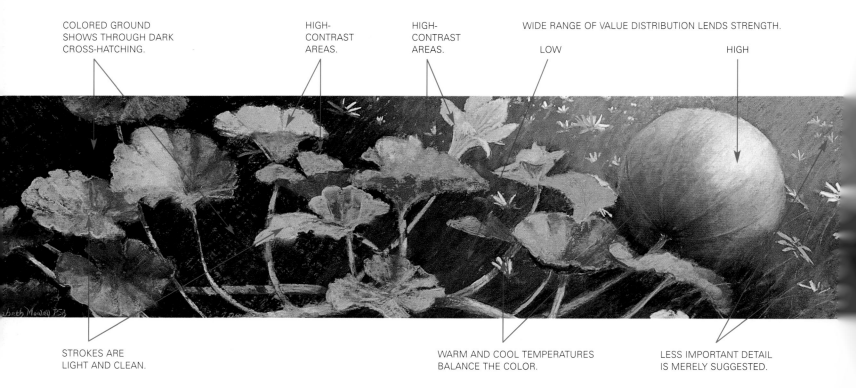

STROKES ARE LIGHT AND CLEAN.

WARM AND COOL TEMPERATURES BALANCE THE COLOR.

LESS IMPORTANT DETAIL IS MERELY SUGGESTED.

WINTERSET PUMPKIN
Pastel on sanded paper, 8 × 30" (20 × 76 cm). Collection of Mrs. Frank Reis.

In late September, this pumpkin was still young, but the leaf-and-vine pattern called to be painted. I intentionally chose a horizontal format because it allows the vine to "grow" across the painting. I began by darkening the ground with Turpenoid brushed over a layer of indigo hard pastel. Because this liquid layer of color sinks into the surface, it does not interfere with the grit's full capacity to accept color, which was essential for the crisp treatment of the leaves. Finally, the suggestion of a few lingering daisies provides a delicate shape compared with the larger, highlighted pumpkin.

Outdoor Still Life

During the final pleasant days of autumn, consider the idea of painting an outdoor still life. Before harvesting, take advantage of the abundance of subjects already in place. Zero in on pears or apples on trees or focus on the ground where they fall. You might be surprised at how often nature's arrangement surpasses our own.

This phase of outdoor still life is short, limited as it is by the unpredictability of weather, but by developing a familiarity with nature's patterns through observation, notes, and sketches, you will discover an expanded offering of evocative subject matter that might otherwise be overlooked.

SEPTEMBER PATTERNS
Pastel on sanded paper, 17 × 13" (43 × 33 cm).
Collection of Kathleen and Stan Boduch.

This is a study of grapevine patterns and shapes as they exist in their own environment. Each season is filled with expanded painting possibilities when natural settings are given consideration. Just remember to get up close to your subject matter. Limit the scope of what you paint, and work at almost life size. Don't be afraid of filling your painting surface.

Some bold, clean painting strokes model the shapes of the grapes, and then broad, short, side strokes paint the background and push against the shapes to give definition.

Bringing Nature Indoors

Eventually, it is time to gather up fruits, cones, and pods, as well as dried flowers and grasses.

As we bring our varied harvest indoors, filling jars and crocks and baskets, the action itself becomes a fresh statement in our work. Nature is now beautifully rearranged in humankind's environment.

As illustrated by the two paintings below, close-up studies are most effective for depicting nature's still-life gatherings.

SOLO AND
SYMPHONY I

Pastel on Ersta sanded
paper, 5 × 20" (13 × 51 cm).
Private collection.

Ripe figs spill their magical color across the format. All climates provide the artist with unique gifts of the season.

THREE APPLES

Pastel on sanded paper,
6¹/₂ × 12" (17 × 31 cm).
Collection of Jim and
Anne Smith.

I sketched these apples with soft pastels on a dark-toned ground, much of which I left untouched. The loose, broken strokes give shape and highlight to the apples. Light cross-hatching suggests the blue table covering. Shadows are soft and indistinct.

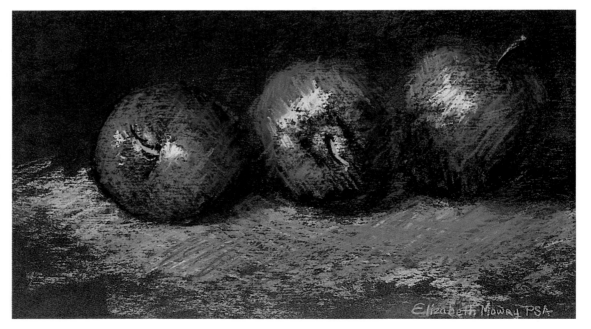

PEARS
Pastel on solid ground,
8 × 12" (20 × 31 cm).
Collection of Jennifer and
Antony Hayward.

After putting in darkest areas with soft pastels, I added some brighter colors to these life-size pears, then carefully modeled their shapes with subtle tones. These pears were painted outdoors at the site where they fell under their tree.

TURNIPS

Pastel on sanded paper, 6¹/₂ × 13" (17 × 33 cm).

The dark-toned ground shows through the lightly applied, soft pastels. Fewer than ten pastel sticks were used to make this pleasing sketch. Complicated still-life setups are generally an exercise in technique. A simple subject, on the other hand, leaves room for the viewer to respond to what is presented.

DRIED BLUE STATICE AND BACKGROUND
DRAPERY ARE SUGGESTED VAGUELY.

HARD-EDGED DETAILS ARE
PLACED AT FOCAL AREA.

NO FLOWER SHAPES IN SHADOW
AREAS ARE AS BRIGHT AS THOSE
IN HIGHLIGHTED AREAS.

LOST EDGES ARE AS IMPORTANT
AS THOSE SHOWN.

HYDRANGEA

Pastel on Wallis sanded paper, 20 × 24" (51 × 61 cm). Collection of Richard and Lisa Oliver.

Finally, at the end of the season, flowers are dried and arranged. Painted on a dark-toned paper, an analogous palette of red violet, blue, and blue violet with a touch of yellow complement creates a low-key still life that keeps color in reserve. Edges lost in shadows make this painting more interesting than if they were visible.

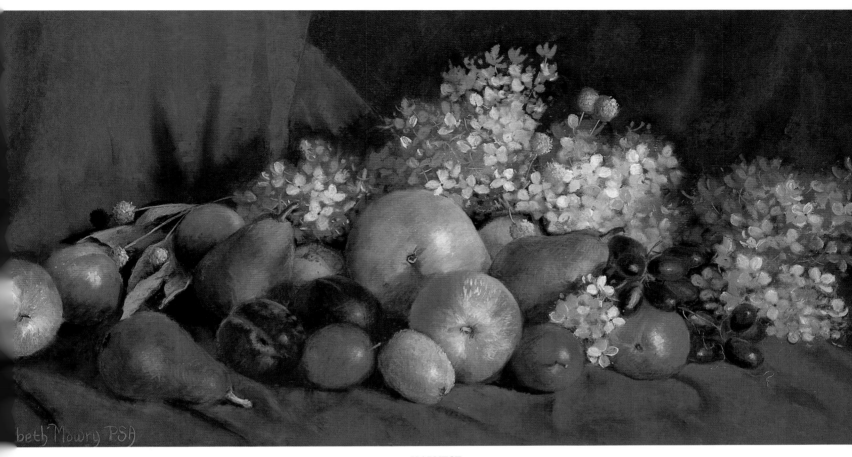

HARVEST

Pastel on Wallis sanded paper, 14 × 28" (36 × 71 cm). Private collection.

Colors enhance one another in this autumn still life. The hydrangea, apples, and green sprigs were from my garden, while the mango, kiwi, and other fruit were brought home from the market to round out the idea of abundance and thanksgiving.

5
Winter

WINTERSET, JANUARY (detail)
Pastel on Wallis pastel paper, 10 × 19" (25 × 49 cm). Collection of the artist.

Morning sun breaks through the clouds and lights up snow that fell during the night. The soft blues and purples of shadows do not compete for attention with the focal point.

A RESPONSE TO WINTER

Winter embraces all the remnants of color from the weary year and then sometimes drops a fresh, white cover over them all. With the addition of snow over the landscape comes the potential for paintings that can be exciting or beautifully quiet.

As you look for subject matter while walking through fields and woodlands, where dry tree branches overhead crackle in the wind, you will notice that a clear sky in winter appears more intense in color than at other times of the year. There is also a great variety in dramatic cloud formations. Dark storm clouds hang very low in the sky. As they hover near the horizon, they tend to stretch out like pulled taffy. Be mindful, too, of the stark beauty of barns and outbuilding shapes against leaden skies.

Be sure to observe winter sunsets; they can be as spectacular as those of other seasons. On your way home from a walk, as you hurry toward the warmth that awaits indoors, take a moment to enjoy the way an early-setting sun colors the sky with rich violet, magenta, and orange just above the darkened horizon. For a few brief seconds, light will swiftly change and change again before it almost explodes with color and disappears.

On moonlit winter nights, witness yet another drama in the sky. Patterns of clouds open and part over and around the moon, hypnotic in their beauty and offering endless material for skyscapes. I happen to love the winter landscape under any conditions, but I find it particularly exciting to allow light in the sky to assume a dominant role over a minimally painted end-of-day snow scene. The end of the year, together with the end of the day, conveys a poignant intensity that I often try to portray simply because I am deeply affected by it myself.

EVERGLADES PATH II
Pastel on Sennelier La Carte, 7 × 19" (18 × 48 cm).

Regions with moderate temperatures even in winter also provide subtle changes throughout the year. These are more likely to find their way into the compositions of artists who are familiar with the regional landscape and know what to look for.

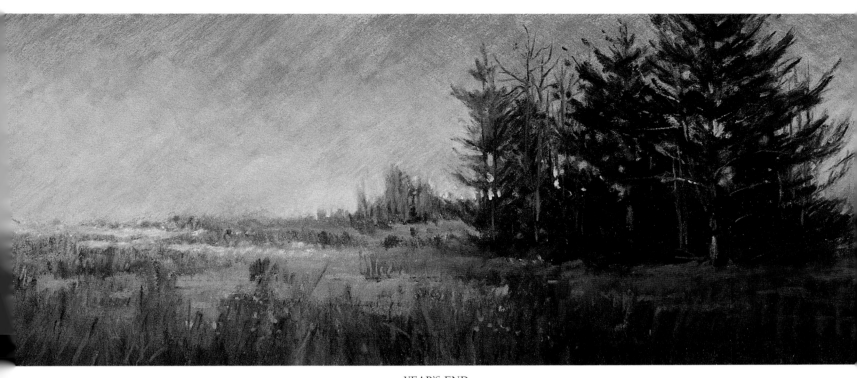

YEAR'S END
Pastel on Sennelier La Carte, 5¹/₂ × 13" (14 × 33 cm). Private collection.

A dramatic winter sunset intensifies the light at the edges of trees and grasses in a darkening landscape. Sky colors are cadmium red light, Naples yellow, violet, and blue, all of which are absorbed momentarily by the snow. In this end-of-day, end-of-year scene, diminishing light in the sky conveys the emotional essence of the painting.

WINTER SHADOWS
Pastel on Sennelier La Carte,
5 × 7" (13 × 18 cm).

This little on-site study is an example of pleasing seasonal contrast provided by dark-green coniferous trees and white snow. Blue shadows weave the two extreme values together.

HINTS FOR BETTER WINTER PAINTINGS

In winter, the landscape is reduced to essentials. Structure, often hidden by foliage during other seasons, becomes prominent. How convenient that nature simplifies itself for us in winter. Fragmented summer foregrounds now appear as one large area under a covering of snow. The autumn field of colorful weeds and varieties of brush is transformed overnight into a mass of white, perhaps divided only by a narrow, ice-edged stream. These large shapes are the strength of this austere season. They can become the strength in your paintings as well.

Examine color closely as you look at winter landscape. In the distance, a jagged tree line might appear purple under skies that range from clearest blue to overcast. Dark-blue mountains that rest behind trees will soften to palest lavender as they recede. The rich greens of the coniferous trees are frequently the deepest (or lowest) value in your winter landscapes. When snow occurs, of course, it will replace the sky as the highest value in your paintings.

On a sunny day, because of the high value of snow color, you will find many contrasts in the landscape. Observe snowcapped rocks rising from a black-green streambed. See the swirling indigo water at the bottom of a partly frozen waterfall. Study the low, graceful hemlock branches above a sunlit, brilliant snowbank. Areas of high contrast can be assimilated into strong landscape compositions that are uncomplicated by the high color of seasons past.

Conversely, notice that on an overcast winter day, the range of light and dark values narrows considerably; it is reduced even more on a snowy day. Some of the most beautiful, emotion-evoking masterpieces, such as Monet's *Ice Floes,* are painted within an incredibly limited value range. Exploring a restricted range of values within a painting is always a challenge, because whenever you purposely hold back contrast, you take the risk of having paintings that appear washed out and indecisive. This is when the painting process balances on the tenuous edge of what will work and what will not. Every step has to be evaluated in those terms. One thing is sure, though: As you try to meet the challenge, you will be enthralled by weather conditions that your nonartistic neighbors find immensely disagreeable.

During winter months, painting outdoors is still possible much of the time in many regions. When the temperature drops measurably, you may need to adjust your painting strategy accordingly. Instead of putting in large shapes first all over your surface, then refining as you continue, you may wish to begin at the focal point, then work outward. This is especially helpful if there are man-made structures in the scene that require extra time to achieve accuracy. Once you complete the center of interest in your composition, block in surrounding natural elements and finish the painting in your studio, working from color notes or a reference photograph.

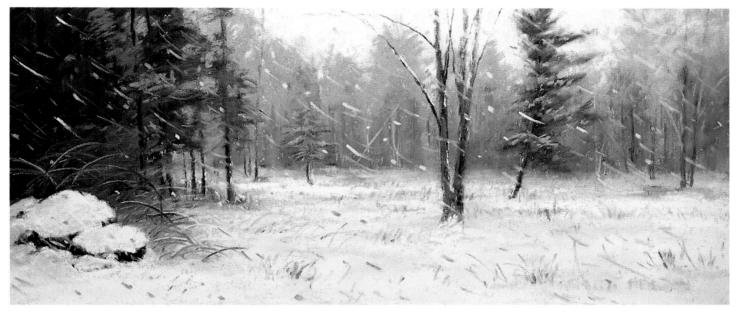

WINTERSET MEADOW
Pastel on Ersta sanded paper, 5 × 15" (13 × 38 cm). Collection of Albert and Gudrun Novak.

Low contrast exists in this small winter painting because a reduced range of values was used throughout. Despite the suggestion of falling snow over the meadow, a sense of extreme quiet prevails. I painted this view from my studio window.

PRELIMINARY: *I started* Winterset, January *(see pages 118–119) by focusing on my house first, getting all the structural lines in place before bringing in landscape details.*

THE WINTER PALETTE

Nature's winter colors are somber but elegant in their quietness. The warm, pure hues of autumn have faded; now, subtle purples and blues dominate a cooler palette.

Compared with earlier seasons, winter may appear lacking in color, but those hues that remain are worth exploring closely. Just glance toward a large mass of leafless trees and you will realize that at no other time of the year can we distinguish so many variations of gray, brown, and purple, each one distinct in its own temperature and subtlety.

Now might be the time to add a few sticks of soft, low-chroma color to your supply of soft pastels. Look for names such as red gray, Van Dyck brown, reddish purple, olive brown, burnt madder, Van Dyck violet, Indian red, black green, purple gray, to name but a few. As you hold four or five of these nonbasic colors together in your hand, you will immediately understand the quiet beauty of muted color that's such an important part of the winter landscape.

If you are not ready to purchase additional sticks of convenient color, with a little bit of time and practice on scraps of sanded paper, you can produce beautifully subtle, neutral tones by using complementary colors together, either blended or left in broken strokes on your surface for the eye to blend.

As you construct the winter palette of color for your region, look for the minute traces of warmth that will complement the cool purples, blues, and grays. They can be found in scarlet winter berries, in lingering sienna oak leaves, or in tall ochre grasses that edge an icy stream. Introducing small amounts of these complements will intensify other colors in your paintings.

In winter, you won't want to be carrying a lot of supplies while trudging through deep snow, slippery mud, or walking over frozen ice. But for quick studies that keep you outdoors just long enough to get down basic information, you need take along only about twenty pastel pencils, which will give you most of the color range to be found in the winter landscape. Together with a small sharpener, they will fit easily into a pencil case. A few small, board-mounted pastel surfaces completes the simple list of supplies needed for outdoor winter studies, to be developed into paintings back in your studio.

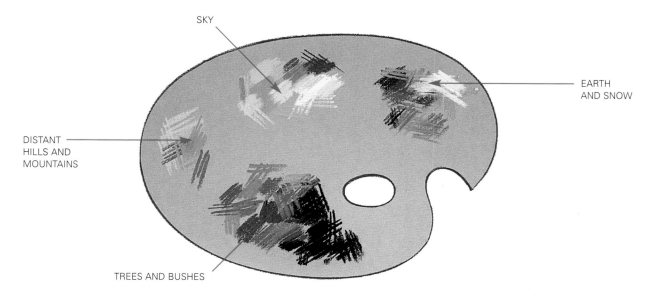

SKY

EARTH AND SNOW

DISTANT HILLS AND MOUNTAINS

TREES AND BUSHES

WILDERSTEIN GAZEBO
Pastel on Sennelier La Carte,
8 × 7" (20 × 18 cm). Collection of William Darwak.

Patterns of light and shadow on a simple structure dominate this winter study. When tree foliage is absent, man-made structures become more obvious.

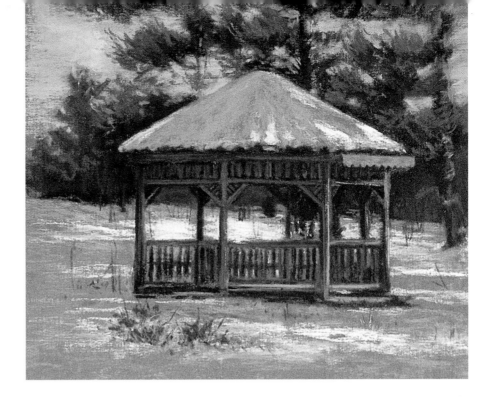

WILDERSTEIN GATE
Pastel on sanded cloth, 8 × 8" (20 × 20 cm).
Collection of Ray and Linda Caddy.

This small study was started with soft pastels and completed with pastel pencils. It provides a little glimpse of winter with minimal color.

125

TREES: WINTER REVEALS THEIR STRUCTURE

Trees are the largest and oldest living things on earth. If we are to be painters of nature, it makes sense to learn something about them—and winter is an excellent time to study their structure.

Observing the anatomy of a specific deciduous tree in winter helps you to capture the expression of that species during other seasons of the year. Just as knowledge of human anatomy is essential for portraying figures, an understanding of a tree's framework is needed in order to paint it with accuracy. And just as clothing won't mask a poorly constructed figure, neither does foliage conceal careless tree structure.

I try to make the acquaintance of one kind of tree each year, watching its changing details throughout the seasons. I suggest that you set just as modest a goal for yourself, so you won't be overwhelmed by the huge variety of tree species nature presents. In fact, for purposes of sketching or painting, you need only look for general characteristics of the kind of the tree you want to depict. When I go to the woods to sketch in winter, I may do several studies, but of only one kind of tree on each outing. If you do the same, choose a tree that appeals to you particularly, and observe its special characteristics.

For example, hickory tree limbs have a different pattern of departure from the trunk than those of the apple tree. The graceful bearing and classic shape of the elm has little resemblance to that of the swarthy oak. Poplars, willow, and cottonwoods all have distinctive, picturesque qualities for you to use in your landscapes.

Soon you will begin to recognize the characteristics of a particular tree species. As your familiarity grows, your drawings and pastel sketches will move from the literal to the more expressive without compromising accuracy. This progression is gradual, but all of the stages of learning can be rewarding and well worth the time and effort you invest.

As you acquire an intimate acquaintance with winter trees, you will recognize that what they lack in bright color is compensated for by form and grace. When nature offers us the thrilling phenomena of change, it is in our best interest to take advantage of this exhibition. With each passing year, I see more deeply, while becoming more and more aware that I am incapable of absorbing all of the changes that I find so interesting. However, another magnificent quality of nature is its continuance. Again and again, winter will return. What I am not able to capture in my work in this winter, I will have the opportunity to try to capture next year.

TIPS FOR OBSERVING TREES

- Scan the tree's height as compared to width.
- Study the trunk color and texture of its bark.
- See how limbs attach to trunk—branches attach to limbs—twigs attach to branches—and note their relative size, taper, and thickness.
- Look for consistencies in the shape and stretch of limbs and the angle at which they depart from the trunk.
- First see generalities, then specifics.

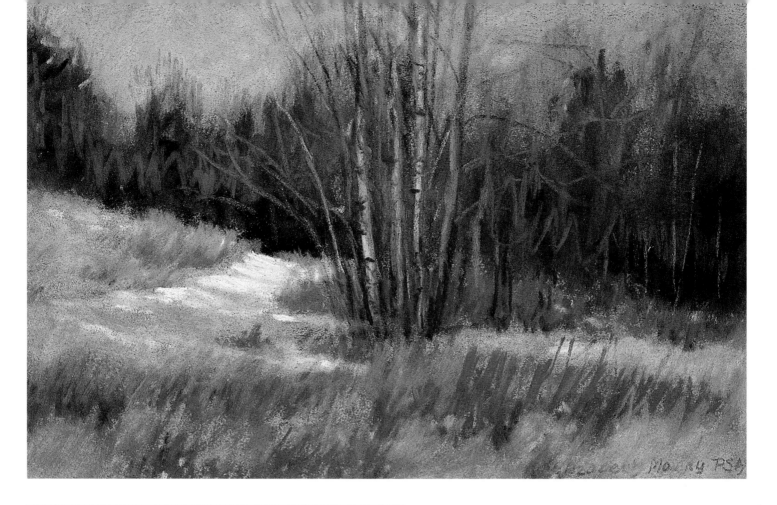

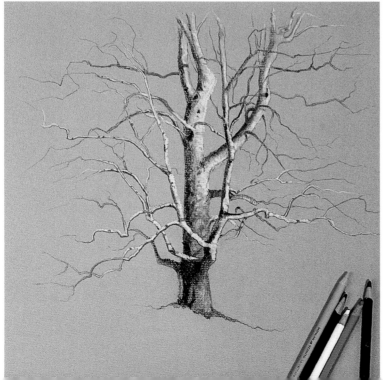

STUDY

Pastel on Ersta sanded paper,

5 × 8" (13 × 20 cm).

Each season has warm and cool color for the artist to use in composing landscape paintings. Here, light on the path leads the eye into the painting.

THE SYCAMORE

Pastel pencil on Ingres paper,

12 × 14" (31 × 36 cm).

In the study of trees, you have an excellent opportunity to use pastel pencils as drawing tools. The five pencils used here are white, leaf green, dark ochre, gray, and black.

127

DEMONSTRATION: *Painting Evergreen Trunks*

Right from the start, I was taken by winter sunlight filtering through these tall evergreen trunks. My little pencil sketch provided the incentive to go for strong contrasts in my painting, and I wanted to show the overall beauty and grace of the trees by focusing only on their sunlit trunks. Simplicity in overall design was my aim. Had I allowed myself to get carried away by the delight of applying more color and detail to dark portions of the painting, it would have lost its focus. In some sections, the darkened surface has no pastel on it at all, and in most places, there are no more than two layers. I treated this painting as a large sketch, getting down what I wanted—then I stopped, pleased with the dramatic, almost abstracted, result.

Painting a portion of a tree can be just as effective as painting the entire tree, particularly if your interest centers on an in-depth study. If you have already painted a type of tree many times, showing its complete shape in your work, you may be ready for a closer look.

STEP 1: SKETCH. *Going through one of my notebooks, I chose this pencil sketch as the springboard for a painting.*

STEP 2: MINIMAL LAYERING. *This detail shows that the full-textured appearance of this painting is not due to a heavy application of pastel, but rather to fresh, rich color side-stroked onto a very dark background. I had stained a buff-colored sheet of sanded paper with diluted dark wood stain in areas where I would want deepest values. In that way, I wouldn't have to overload the surface with pastel in an attempt to get rich, dark values. With minimal layering, the lightly dragged side-strokes of soft pastel leave a gritty pattern on the surface that would not occur if several layers of pastel had already begun to fill the tooth.*

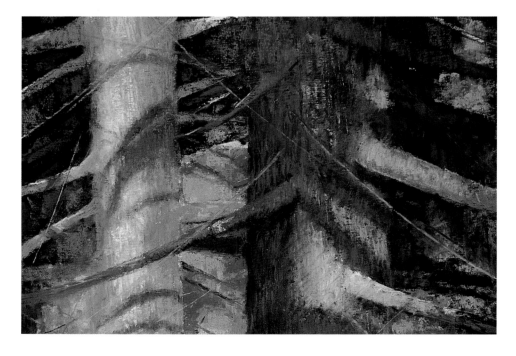

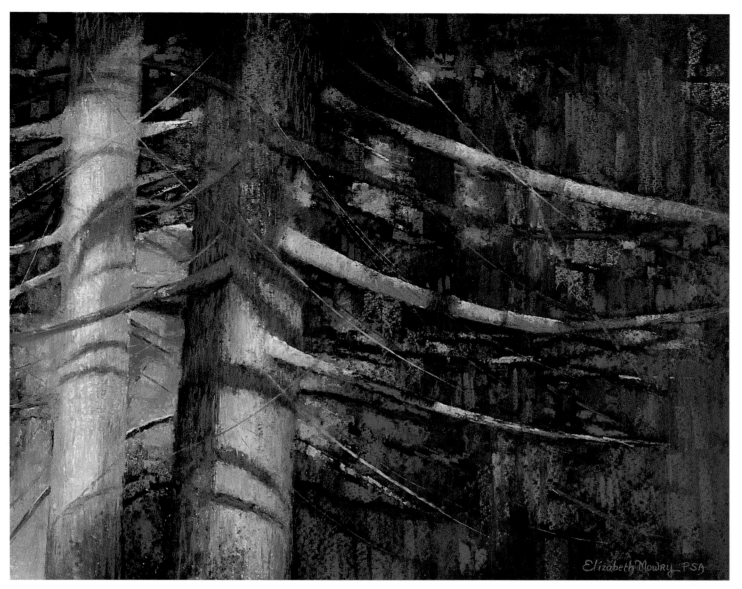

SUNLIGHT ON NORWAY SPRUCE

Pastel on sanded paper, 22 × 28" (56 × 71 cm).

STEP 3: FINAL, LIGHTER VALUES. *After I lightly sketched the trunks and main limbs on my dark surface with gray pastel pencil, I stroked in low-value purples and greens, and a lighter value of blue for the sky, using soft pastels on their sides. Ochre, deep purple, and several values of pink and red violet were worked into the trunks; cast shadows are cool purple.*

PAINTING WINTER'S CHANGING MOODS

During winter in many parts of the world, snow accumulates to become a temporary addition to the earth's surface. Like other horizontal surfaces, it is directly affected by the light in the sky above it. Fine-tuning your perception, and learning to convey the qualities of absorbed light, will give you the key to painting mood into your winter work.

Depending upon the time of the day and color of light in the sky, snow can appear blue, purple, pink, yellow, orange, blue green, or another color. On the opposite page are two studies that illustrate how light in the sky affects the color of snow, and therefore, the tone of the painting. Another example, below, shows how the artist can manipulate color temperature to create mood in a winter painting.

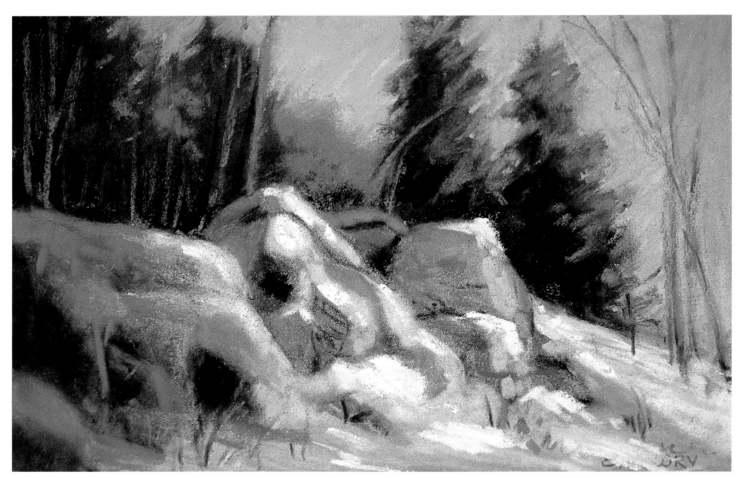

A lavender sky would cool this small study considerably.

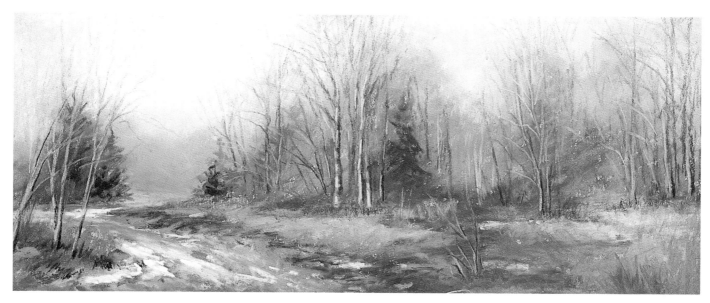

THAW I

Pastel on Ersta sanded paper, 5 × 12" (13 × 31 cm).

Effects of color temperature work best when they are consistent throughout a painting. A cool sky here suggests a crisp February day.

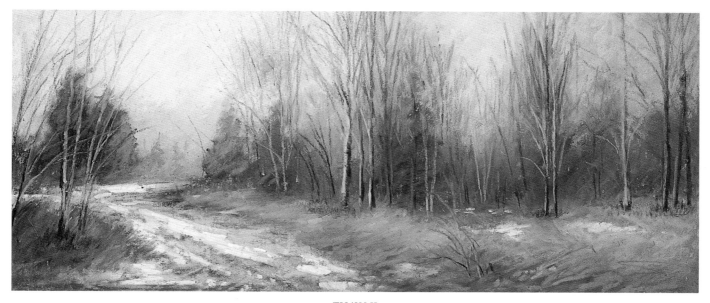

THAW II

Pastel on Ersta sanded paper, 5 × 12" (13 × 31 cm).

As compared with Thaw I, *warmer sky color in this version shows color adjustments in all areas, including the snow and dried grasses. These changes evoke an overall different mood.*

Choosing the Mood

When you work from a pencil sketch or charcoal drawing, as is often the case in winter when weather limits the time you spend outdoors, the mood of your painting is your choice. Start with the sky and visualize your scene in several ways. For example, picture it on a clear day with a blue sky; imagine it under a warm, yellow sky; visualize it at dusk, with a rosy light over the darkened landscape. Do a few small color studies before making a choice. Then, be faithful to your decision. Save the other possibilities for future paintings. Just make sure that within your chosen color theme, based upon the color of the sky, you cover the full range of values that your sketch requires. Try colors together on a scrap of the same surface you will be working on. If you like how they interact next to, over, and under one another, chances are you will be pleased with the color harmony in your painting—in essence, simply use your sky color in other parts of your winter painting, including the snow.

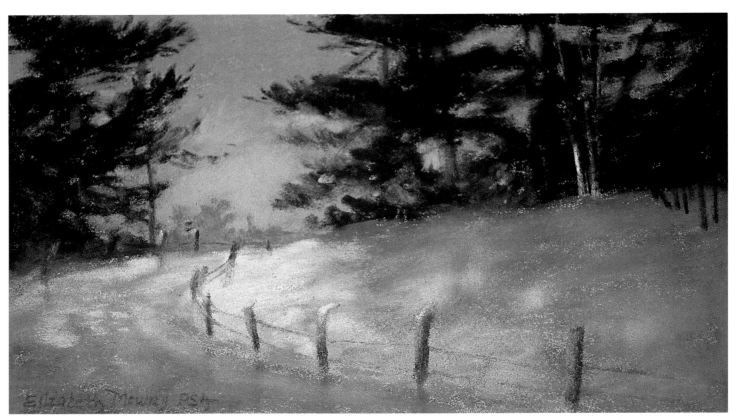

In this small color study, a blue sky is reflected in areas of snow along the winding path.

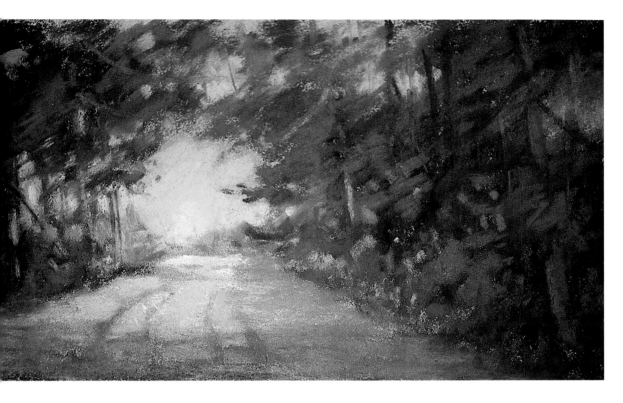

The color of snow is always affected by the color of a winter sky reflecting upon it. Here, the result is a pink glow.

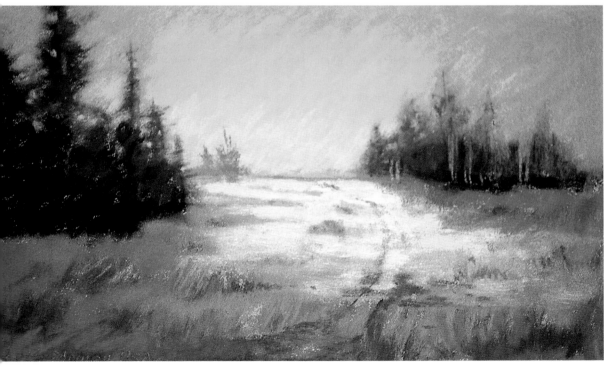

Nature provides endless variations for the artist— in all seasons. Even at the height of winter, a bright yellow sky casts a warm glow on a blanket of snow.

Painting an Overcast Landscape

On overcast winter days, snow appears to lose all contour. The sunny-day, high-contrast changes in value are now gray and flat. Unless you have a specific reason for portraying those qualities, they are probably best left out of your winter landscapes.

I find that on gray days when no strong shadows exist, reality can be a hindrance—so once I leave a gray and lifeless scene and go back to my studio, I feel more free to visualize color and mood and work it into my sketch. I always begin with the sky. Do I want it to be dominated by blue green, palest saffron, or lavender? Once that decision is made, I try to imagine how the selected sky color would affect the tonality of other components in my work, visualizing how a sky-colored transparent veil or glaze would look dropped over my sketch. This simple visualization gives me a general idea of what I will be aiming for in my pastel interpretation of the sketch.

Next, I choose colors with that unity in mind, and include a trace of complement for color vibration. Even though I'm setting the overall tone for the painting, I may add colors later as needed. Whichever colors I choose, one thing is certain: I will have several values of my chosen sky color at hand. In that way, with light cross-toning, I can relate any area of the painting back to the sky tone and keep my color theme intact. Taking risks makes this a very exciting way to work.

WINTERSET

Pastel on Ersta sanded paper,

14 × 25" (36 × 64 cm).

Collection of Andrew and

Ingrid Novak

On a sunny day, this scene would have been painted with much more contrast; here, on the morning after a snowfall, the light in the sky was still weak, and the range of values is narrower.

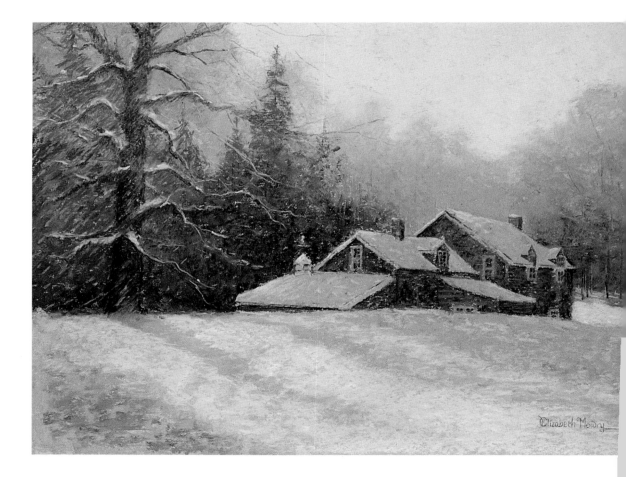

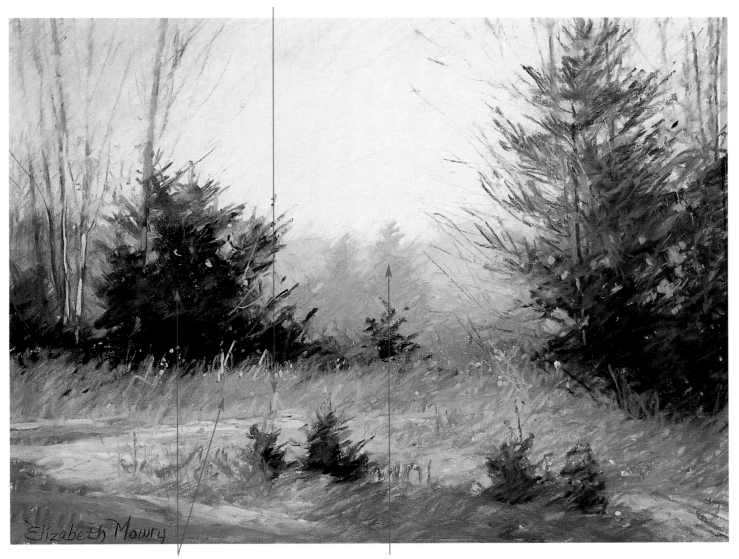

UPRIGHT GRASSES SUGGEST
THE ONSET OF WINTER.

WARM COLORS IN GRASSES
COMPLEMENT DARK-GREEN
CONIFEROUS TREES.

BLUE-GREEN BACKGROUND COLOR IS
SLIGHTLY EXAGGERATED TO SUGGEST
ATMOSPHERE, RATHER THAN DISTANCE.

COLORS ARE REPEATED
THROUGHOUT THE
PAINTING.

ALBUQUERQUE WINTER

Pastel on Wallis sanded paper, 12 × 16" (31 × 41 cm).

In this transitional painting, snow has not yet covered all of the withering grasses. Where the end of one season overlaps the beginning of another, an opportunity presents itself to the artist who is open to more than the obvious characteristics at the peak of a season.

135

DEMONSTRATION: *Working from a Winter Sketch*

Montgomery Place is a restored mansion along the Hudson River that is now open to the public. Although the mansion is impressive, I felt more attracted to an uninhabited cottage on the estate. Surrounded by wild vine growth and what may have once been a garden, at the time of my sketch it was a vacant structure situated in deep snow that was penetrated by obstinate weeds. Everything about the place called out to be painted, and I knew from the start that someday I would do that.

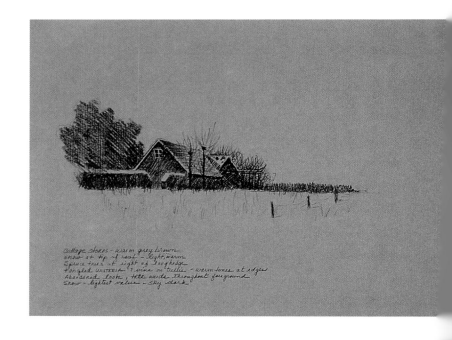

STEP 1: INITIAL SKETCH. *In this small pencil study done at the scene, I was concerned mainly with lines of the structure. I had also made a few notations about the source of light and color of the stone cottage, but was determined not to be tied too much to reality.*

STEP 2: SETTING UP VALUE DIFFERENCES. *Some time later in my studio, I visualized this scene as cool, quiet, and blue. I decided on a palette that would be simple and cold, except for some light on the snow—with a bit of warm complement in the weeds. I did a minimal sketch on my surface with gray pastel pencil, then used soft pastels on their sides for rapid, even coverage. Three light layers of color in the sky provide an adequate base of pastel before blending the colors into one another with a blue-gray hard pastel.*

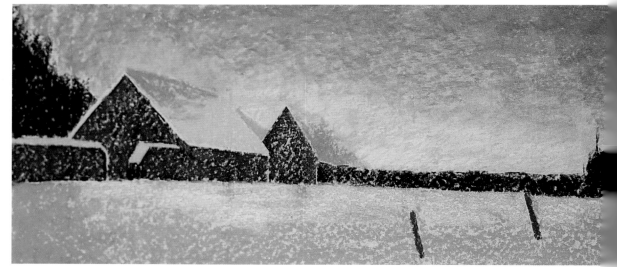

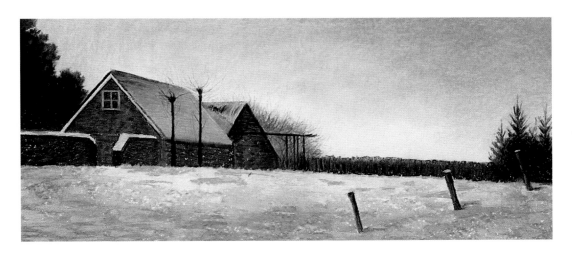

STEP 3: REFINING COLOR AND SHAPE. *After extending evergreen edges into the completed sky, trees and vines are drawn in. I use blue and purple soft pastels for foreground snow, drawing on my memory of the place for color selection. Being away from the reality gave me the freedom to exaggerate the snow colors for effect.*

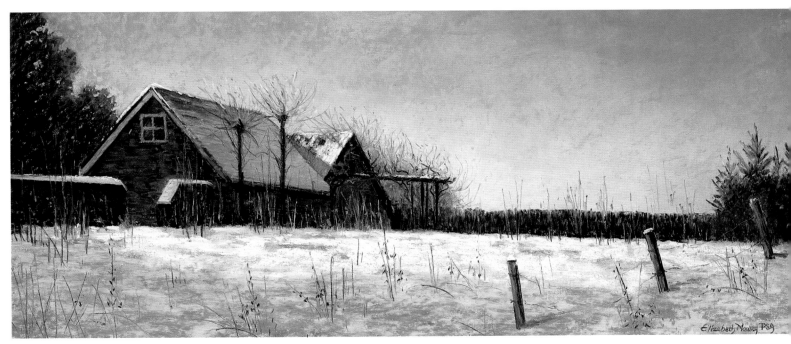

GARDEN COTTAGE AT MONTGOMERY PLACE
Pastel on sanded board, 13 × 31" (33 × 79 cm). Collection of James and Judith Embree.

STEP 4: FINAL ADJUSTMENTS. *Even with an abundance of snow on the ground, warm-hued grasses, weeds, and vines catch the light. I use a tint of Naples yellow on the snow, attach wire to the posts, and break up the solid evergreen mass with a few sky holes, then refine and adjust overall color.*

USING SHADOWS FOR INTEREST AND FORM

Snow is a covering. Unless wind interferes by causing snowdrifts, it generally conforms to the contours it covers. If there is something between sky and ground, snow will accumulate on that object first, and less will fall on the ground. These facts are elementary, but sometimes we forget to apply all that we know to our paintings.

When snow continues to fall on an open area such as a large field or pasture, it will eventually cover the interesting grasses, the tractor road, and walking paths. In short, details disappear. Now is the time to celebrate the beauty of simple form, which is more clearly evident in winter than at any other time.

A large expanse of white can be very dramatic in some paintings. In others, the large, light area will appear more interesting if painted at a time of day when nearby objects embroider their purple-and-blue shadows across the surface and lead us over contours of the land beneath.

Striking foregrounds in snow scenes can be created by using shadows as a prominent compositional element in your painting. Use shadows to send the viewer's eye wherever you want it to go.

Morning and afternoon send shadows in opposite directions; visit a favorite place at both times to compare what happens. Avoid limiting your shadow study to those that stretch horizontally across your landscapes. Use creative angling that you control by facing the sun or source of light a little more directly, and you will see the shadows reach toward you.

Shadows show us the roll of the land, the tractor ruts we no longer see, and the paths that have been lost. Shadows write the story of snow-drenched fields for the artist.

LITTLE STREAM
Pastel on sanded paper,
6¹/₂ × 10" (17 × 25 cm).
Private collection.

I liked the shape of this bit of water carving its way through a field. The warm ochre of grassy weeds is repeated in the stream's reflected light, providing a complementary balance to the cool, blue-purple snow.

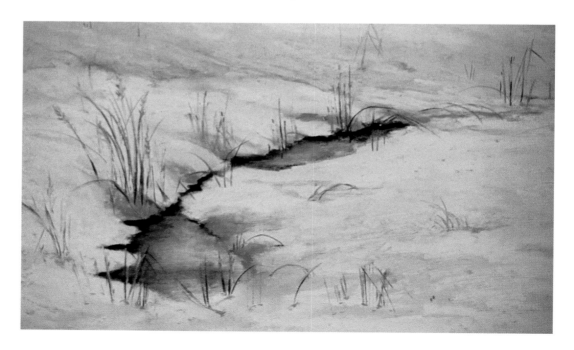

SNOW MAKES THE BRANCH CHARACTERISTICS OF THE WHITE PINE RECOGNIZABLE.

SOME OF THE BRANCH EDGES CATCH THE SUNLIGHT.

SNOW PICKS UP ITS COLOR FROM THE SKY.

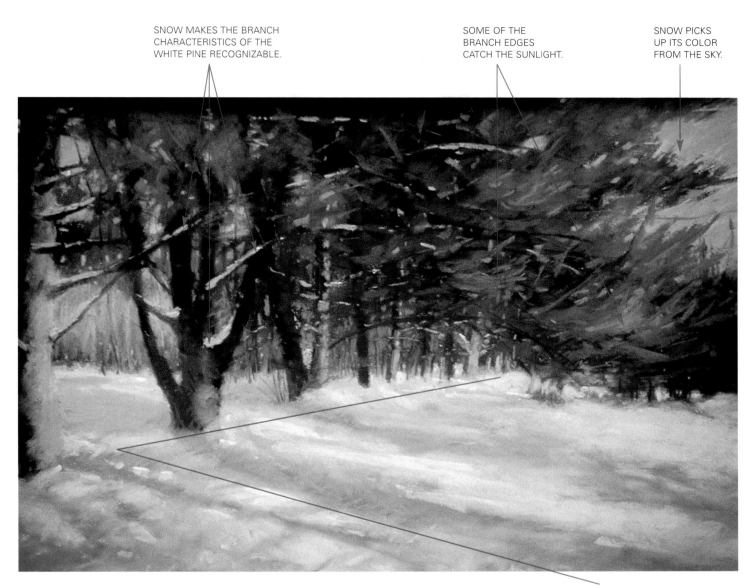

THE DIAGONAL TREE LINE CORRESPONDS TO DIAGONAL SHADOWS, ADDING INTEREST TO FOREGROUND SNOW.

MARCOTT SNOW SHADOWS
Pastel on Wallis sanded paper, 10 × 16" (25 × 41 cm).

Diagonal shadows lend interest to the foreground of this painting of white pines. Use shadows as an important part of your composition, rather than simply as an afterthought.

ZEROING IN ON NATURE IN WINTER

When standing above a vista that spreads itself out before us in all of its grandeur, we are likely to feel flooded with a keen appreciation for all of nature. Many of us can remember how we felt hiking up a mountain with friends—breathless, but conversing all the way, happy to be with kindred souls and so close to the clouds on a perfect day—then, as we reached the top, experiencing those first few moments of blessed silence as we took in a view that any words would ruin.

Between those unique adventures, it is possible, almost daily, to experience fresh insights into small fragments of nature. Zeroing in on nature is easier to do in winter than in any other season because of the way landscape is reduced to basics. With the frills of other seasons gone and snow covering fields and woodlands, details are greatly diminished. What remains becomes more precious, more worthy of

closer scrutiny. As we walk along familiar paths during winter, we no longer merely notice changes; we also begin to search for changes to notice. This turning point could be the beginning of a love affair with your surroundings that enhances both your life and your paintings.

What to zero in on? Check out those matted weeds that throw deep violet shadows across the snow in abstract designs. Visit the blackberry patch out of season and note the criss-cross, purple arches of its fruitless bushes. Examine the brilliant color inside iced-over rose hips. How about those daisy heads in the meadow, petalless and broken, but still alluring? Get up close to see detail. Whether you choose to paint or eliminate detail is irrelevant. Seeing things close up enlarges our understanding of them, and understanding subject matter and its parts makes better paintings.

DAPPLED LIGHT

Pastel on Sennelier La Carte,

5 × 7" (13 × 18 cm).

This winter composition zeroes in on the edge of a pond where water was still resisting a freeze. I am attracted to areas of snow where sunlight and shadow dance.

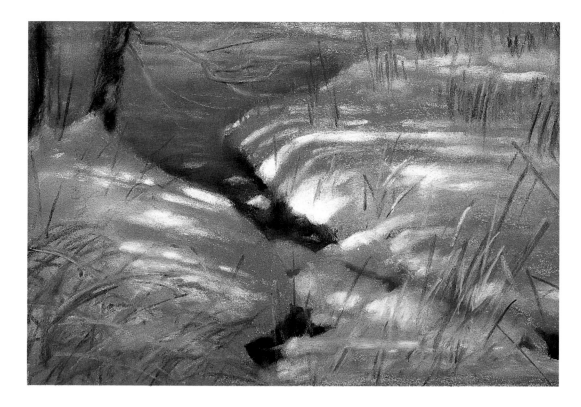

DEMONSTRATION: *Closing In on a Simple Subject*

Students visiting my studio are sometimes impressed by studies of small parts of nature, such as a few strawberries or a tiny stream making its way through the snow. I often wonder why they take note of such simple sketches, but I have come to realize that it has nothing to do with admiring my technique or skills. What delights and touches them is that I have selected so simple a subject—one that they have recognized as well—and that I had found worthy to paint.

STEP 1: INSPIRATION. *The gracefulness of this snow-draped tree caught my eye on a sketching hike through the woods. In the backpack pictured, I had small pieces of sanded panel, twenty pastel pencils, an orange, a blanket, and a folding stool. Thus equipped, I decided to do a small color sketch.*

STEP 2: BACK AT THE STUDIO. *Referring to my hasty color sketch, I lightly drew the fallen tree on 8 1/2-x-10" sanded paper. Then I applied several values of soft pastel to begin what would be the snow.*

STEP 3: FINISHING DETAILS. *I used dark values on the tree trunk and some of its limbs, then added secondary branches. When I painted shadows on the snow and saw how those contrasts enhanced the painting, I accentuated them, then placed a few weeds in the foreground to complete the painting.*

EVERGREENS IN THE WINTER LANDSCAPE

During summer or autumn, a scattering of evergreen trees and bushes in a deciduous woodland would hardly call attention to itself. But in winter, after leaves have fallen, those evergreens become more prominent.

Nature's complementary balance is exemplified within the evergreen itself. Above a circle of fragrant sienna needles fallen to the ground, green branches extend outward from a red trunk that lights up in the sun.

Color variety within the types of evergreens is also more extensive than we tend to think. Of course, the hue of blue spruce is obvious, and even a novice can plainly see color differences between the bright green, long-needled pine and the dark mountain laurel. But it takes a keen eye to pick up a rich sienna glow at the edges of a red cedar. Aside from highlights and shadows, many subtle nuances among numerous species can be used to enhance both backgrounds and foregrounds in paintings that include evergreens.

When painted en masse, evergreens provide a striking backdrop for other compositional elements, such as a meandering stone wall, a snow-covered roof, a frozen pond, or a mottled sycamore tree. Placed prudently, a stand of evergreens will tell something about the contour of a pasture, the distance of a background, or the slope of a snowdrift.

Use distinctive evergreen shapes and even branch direction to strengthen the design of your compositions. A red spruce sends branches that tend to stretch upward in even configuration, whereas those of the eastern white pine are more erratic in shape and length. The balsam fir, in addition to being the most fragrant of all evergreens, is distinctly pyramidal in shape. Hemlocks, though spindly and flat when young, mature to lofty height, with gracefully drooping limbs.

Background Evergreens

A gray or brown band of deciduous trees in a winter landscape becomes more interesting when it is interrupted by the tips of random evergreens. Along with the sienna-toned oak leaves that linger until pushed off by new buds in spring, the deep colors of pines and hemlock add variety to winter palettes.

To bring background evergreens into the picture, use the squared edge of a pastel to simulate an entire distant tree line, with no fussing or overworking. Evergreens will appear farther away when you incorporate some cool blue or purple when painting them. You can also add more distance to background evergreens as you near completion of your painting by cross-toning with gray-blue strokes, which will make trees recede dramatically. Just be sure their size is proportionately smaller as well, and keep the edges soft.

Atmospheric subtleties can be obtained by blurring edges of trees or other objects with a tortillon, or try stroking the sweeping movement of a few snowflakes—but avoid overdoing it, or your painting will look contrived.

Close-Up Evergreens

When painting the needled branches of a coniferous tree, consider the character of the entire tree. Avoid rendering each needle; that is the surest way for something that could be sublime to become ridiculous. When placing tree limbs, strive for fluidity in your strokes. If you have to retrace small branches, your movement is likely to be hesitant, and the double stroke may be thicker than you intended it to be.

Leave some sky spaces—more than you need at first—then put in some middle-value color masses at the densest parts of the tree. Now begin refining the edges of each mass. Perhaps you would like to join some of the masses and extend others with edge strokes that push in the direction toward which the branch is growing. Step back so that you do not overdo this step, because very little detail quite often tells enough.

Here you can see how, under some winter atmospheric conditions, trees appear less distinct. You can do this by cutting the contrast with blue or gray pastel.

Even close-up evergreens can be painted in a loose stroke. Practice going for the overall tree shape rather than its separate parts.

DEMONSTRATION: *Building an Evergreen Tree*

Before painting an evergreen, plan it around a well-proportioned trunk, with a tapering limb and branch structure. This will help you determine where the massed shapes will appear most dense. Put those in with broad side strokes, using small pieces of pastel on their sides. Work quickly and cleanly, and above all, without detail.

Save definition for the edges of masses—the only spots where textured detail is clearly noticeable.

Next, gently build up the warm, highlighted portions of your tree. Introduce cool darks as needed into areas of shadow as you model your tree, giving careful attention to subtle gradations rather than abrupt value changes.

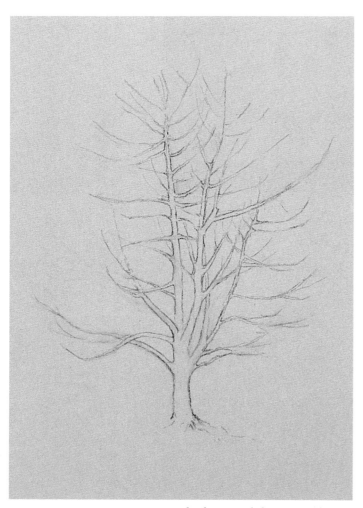

STEP 1: STRUCTURE. *A tree is built around the structure of its trunk, limbs, and branches. Using free, fluid strokes here will give your finished tree a natural, rather than a stiff, appearance.*

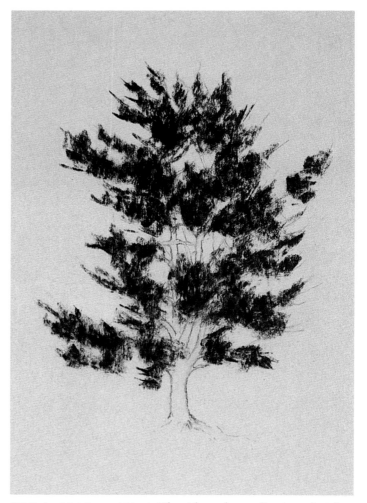

STEP 2: COLOR MASSES. *The side-stroke application of middle-value color masses describes parts of the tree where most density occurs.*

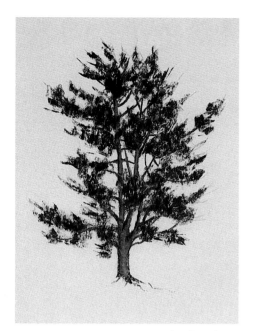

STEP 3: COLOR TRUNKS. *Apply color to the trunk and branches, using light and dark values.*

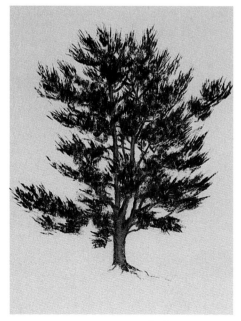

STEP 4: LINKAGE. *Now link up masses and define their edges.*

WHITE PINE

Pastel on sanded paper, 12 × 8" (31 × 21 cm).

STEP 5: FINISHING TOUCHES. *After adding a little more mass, highlights and shadows model the tree to complete it.*

145

LATE WINTER'S TRANSITIONAL PALETTE

Within the woodland's quiet shadows, reluctant snow holds fast awhile longer, but wherever the sun penetrates, the earth's warm, matted colors begin to reappear. Wet, tangled grasses remain low, broken, and decayed. In the clearing, where large evergreens prevented much snow from reaching the ground, the late season's sun changes blue snow shadows to exposed circles of red-brown, sweet-smelling needles.

Since the showiness of early winter is gone, many people regard the end of winter as a dreary scene. Instead, consider adding ochre and sienna back into your palette, for as soon as the ground softens underfoot and sap starts to run, new growth begins. Nature's cycles continue, and spring's new beginning is about to unfold.

THE STONE WALL
Pastel on sanded paper,
18 × 24" (46 × 61 cm).
Private collection.

This painting explores winter's transitional palette, in which warm earth colors temper the coolness of diminishing snow. The absence of life and movement conveys the solitude of a woodlands setting. But soon, as sunny afternoons start to uncover the soggy ground, signs of a new season will appear.

END OF FEBRUARY

Pastel on Ersta sanded paper, 14 × 24" (36 × 61 cm).

Warm and cool color complements enliven this painting, which shows the beginning of seasonal transition. Early waning sun still throws warm light over fields of matted grass, where warm afternoons have melted much of the snow.

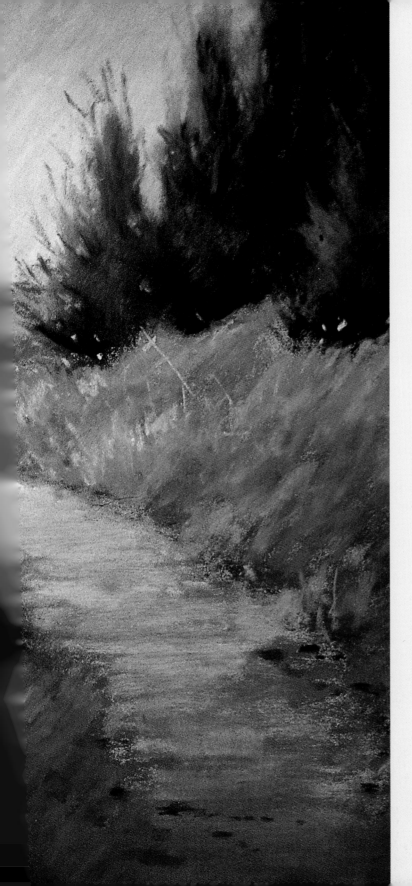

6

Pastel Travel Adventures

CANYON ROAD (detail)
Pastel on Wallis paper, 11 × 19" (28 × 48 cm).

This sketch, made in California, shows how complementary colors can bring vitality to very simple subject matter.

PLEIN-AIR PAINTING

Travel to distant places has become increasingly popular among artists, especially those who enjoy painting land-scapes on location. No matter where an artist lives, travel to other places frequently offers diverse landscape qualities and seasonal changes that differ from those experienced at home.

When workshop participation or other painting vacations require travel, especially by air, there are many factors to consider to make living and painting in new sur-roundings conducive to good work. Careful planning can make the difference between a successful adventure with a happy ending or an experience clouded by frustration and fatigue. Here are some tips to ensure that your long-distance travels with pastels are all successful journeys.

Travel Easel

Just as you would not take the entire contents of your kitchen, including the sink, on a camping trip, resist taking all of the art supplies in your studio on a painting trip. Particularly, heavy wooden folding easels have no place on trips that require air travel. Even with most surface travel, it makes no sense to carry such furniture around from site to site, on and off buses, boats, bicycles, or vans. Reserve your French easel for work at sites easily reached from your home by car. For foreign or other long-distance travel, when you must be prepared to carry everything yourself without assistance, a lightweight alu-minum folding easel is your best companion. Be familiar enough with it beforehand to set it up yourself, which should take only a minute or two.

Surfaces and Supports

The painting surfaces that you take along should be ready to use and totally familiar to you. Never take one that you haven't tried and are sure will work for you. If you paint on toned surfaces at home, take time to prepare them before you leave. I usually travel with various surfaces in small to medium sizes.

Although your usual surface support may be a heavy painting board when you work at home, consider using Fome-Cor (two 12-x-16" pieces) for travel, even if that brand of lightweight panel may not be your first choice otherwise.

When packing up your materials, always remember that locations may require considerable walking. Out of consideration for your fellow travelers who may be good-natured but who have their own supplies to carry, be sure that you can manage without assistance—and with a smile.

Pastels

You do not need hundreds of colors for plein-air paint-ing. If you take between seventy and eighty sticks of soft pastel colors, about ten hard pastels, and a dozen pastel pencils with a sharpener, it will be more than enough. While many artists create finished paintings while travel-ing, I strongly suggest that your approach to work in a beautiful foreign country be primarily sketching—capturing essentials while enjoying the overall experience. Back up your sketches with some photos that show various possi-bilities for developing your studies into finished paintings once you've returned home.

This lightweight folding aluminum easel is the one I use for plein-air painting when traveling by air. Folded up, it fits into a heavy cardboard tube (from a carpet distributor) that I had cut to fit into a 36-inch, zippered case with shoulder straps. An alternative is a pochade box that can be attached to a tripod and is easily transportable.

Here is my travel easel all set up and put to work on location in the French countryside of Provence.

ROCKY MOUNTAIN BLUES II
Pastel on Wallis paper, 8 × 18" (20 × 46 cm). Collection of Dr. Peter and Janie Hutchinson.

One of the joys of travel workshops is discovering new vistas. This was created as a class demonstration to show distance. It also illustrates how color complements work together, even when edges are very soft.

ENJOY DIVERSE SETTINGS

One of the most enjoyable aspects of painting abroad is the chance to explore unfamiliar settings, not only to inspire our art, but to enhance our understanding of the world. However, if you expect yourself to do studio-quality work that is large in size and in scope, it will be difficult to take full advantage of your reason for leaving home in the first place: to see many wonderful landscapes that are new to you, and to experience the fun of a different culture, language, cuisine, and people. When you put unreasonable demands on yourself within a limited amount of time by trying to create finished masterpieces at each site, you set yourself up for frustration.

On a personal level, I learned a valuable lesson in this regard while traveling in France. One market day in Saint-Rémy-de-Provence, it would have been a pity if I had spent the whole morning at only one place, thereby missing the intriguing diversity of the village: seeing fourteen barrels of differently prepared glistening olives at one spot; the warm sunlight on wooden canisters of jewel-colored spices at another; the twinkly smile of an elderly vendor offering the best-tasting apple I had ever eaten; the colorful blue-and-yellow fabrics, handsome olivewood utensils, and the sweet smells of herbs de Provence mingled with lavender sachets. For me, those memories and many quick sketches I made that day are far more lasting and valuable for use in my future paintings than any single work I might have created during those same few hours of time.

This 5-x-10" experiment was inspired by a view of the Seine. It showed me that even such a hot color can be used in a sky. However, in order to maintain a quiet mood, the landscape itself had to be painted with subdued color to avoid tension.

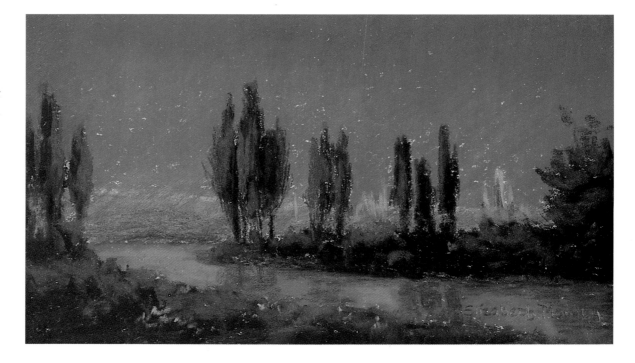

Each of these small vignettes, made in Provence, was completed in a little more than an hour's time. When you wish to do several sketches at a location, take a few photographs first, and then enjoy the experience of on-site sketching. Begin by carefully placing what interests you most on your paper, then work outward as time allows.

Photo Ops

Sometimes en route to a specific painting location, a fifteen-minute photo opportunity will be announced by a tour guide. Workshop participants photograph or sketch something special along the way. You may wish to take a few pictures first, then quickly sketch for the remainder of the time allowed. If the subject is complicated, you can apply a few broad strokes of generalized color on a smooth surface, then with a black pen, capture the essence of place with line. Later, based on your photograph, you can add more color to your spontaneous sketch.

For this sketch on a toned Sennelier La Carte surface, I blocked in a few wide strokes of white pastel and sketched the structures with black pen. Someday, based on my photograph, I will add some color.

LEFT: *This photograph of the interesting Roman aqueduct Pont-du-Gard, in southern France, was taken at a morning painting session.*

BELOW: *An on-site sketch that I made of the Pont-du-Gard may serve as a guide to the size and scope of a scene to record when you are deciding how much to attempt at each painting location. Factors that will influence your decision include how organized you are, which cuts down setting-up time; how complicated the subject matter is; and your own comfortable working pace and ability to remain focused.*

MINIMIZE TO MAXIMIZE

To make the most of a two-week workshop or other brief painting tour, time is a primary consideration, and we are constantly called upon to make wise decisions as to how we wish to use it. Traveling light so that you are ready and able to move about unencumbered by excessive equipment is the best time-saver of all. Let me summarize my recommendations for easy, efficient, and successful painting trips.

Here's what I take on long-distance painting excursions: my lightweight aluminum folding easel; an assortment of seventy-two landscape soft pastels, plus a small box of favorite colors; a dozen pastel pencils; a few hard pastels; tape, scissors, and a small sharpener; various prepared surfaces in small to medium sizes; and two 12-x-16" Fome-Cor panels.

Separately, the Fome-Cor panels act as my drawing boards; together, they serve as a portfolio for transporting my sketches in my suitcase. I cover all sketches with glassine and tape them securely, one by one, within the panels, preventing any movement of the artwork in transit.

I promise, that by minimizing your travel gear, you will maximize the pleasure of your pastel travel adventures.

On-site work like this is spontaneous and fun, and can be used as reference for more extensive studio work later. At a beautiful location, there may be many possible paintings to record on film for future work. Even after exploring with your camera, several hours may be available for sketching or making small painting studies.

LEFT: *This on-site vignette of Saint Paul's Maison de Santé at Saint-Rémy-de-Provence was made quickly so that I could move along to capture other enticing parts of the scene.*

ST. PAUL'S MAISON DE SANTÉ
Pastel on Wallis paper,
9 × 13" (23 × 33 cm).

BELOW: *My finished painting was completed back home, using the above sketch and back-up photos that I had taken at the site.*

THE EMPTY NEST
Pastel on Ersta sanded paper,
18 × 22" (46 × 56 cm).

Notice the use of yellow greens and blue greens to define shapes in this quiet summer painting. Variations in color temperature with value changes add strength to a simple palette.

I made this on-site sketch of cypress trees during a workshop demonstration, one of many that day as we changed locations frequently to take advantage of nature's bounty.

A landscape near Saint Paul's, where Van Gogh lived and painted for a time, inspired this "paint-along" demonstration sketch, which took place during an afternoon workshop session. Whenever you attend a workshop, if your instructor paints on-site, you may choose to watch and ask questions or to paint along. It's also helpful to see how different subject matter is approached by other painters in the group.

INDEX